Drawing on Archaeology
BRINGING HISTORY TO LIFE

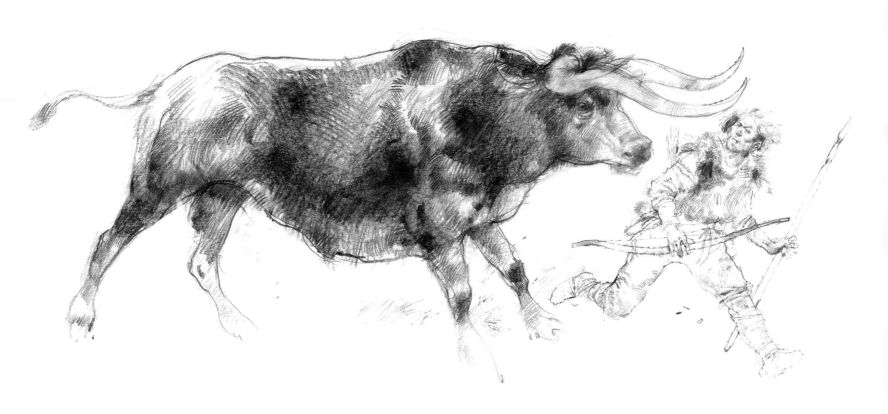

Drawing on Archaeology
BRINGING HISTORY TO LIFE

Victor Ambrus
FOREWORD BY MICK ASTON

First published 2006 by Tempus Publishing

Reprinted in 2010, 2021

The History Press
97 St George's Place,
Cheltenham, Gloucestershire, GL50 3QB
www.thehistorypress.co.uk

British Library Cataloguing in Publication Data.
A catalogue record for this book is available from the British Library.

ISBN 978 0 7524 3144 4

Typesetting and origination by
Tempus Publishing Limited
Printed by Imak, Turkey

Contents

	Foreword	6
	Preface	7
ONE	Prehistoric life and animals	9
TWO	Rural life	17
THREE	Burials, rituals and religions	29
FOUR	Life in towns and cities	47
FIVE	Trade, craft and industry	59
SIX	Life in forts and castles	77
SEVEN	Wars and warriors	85
EIGHT	Crime and punishment	99
NINE	Royalty	105
TEN	The antiquaries	115
	Index	120

Foreword

It is a pleasure to welcome this second collection of drawings and paintings by Victor Ambrus. The first was published as *Recreating the Past* in 2001. Victor has been illustrating historical themes for many years now and has been the reconstruction artist for the *Time Team* series of television programmes for Channel 4 for all 14 years of its existence – now well over 150 programmes. For each episode there are reconstruction drawings and for many there are colour paintings as well.

Over the last 14 years many sites have been visited and a huge range of topics in a large time have been covered. Here are a selection ranging from dinosaurs, through prehistoric themes, right up to Second World War aircraft. For each, Victor brings his unique style and viewpoint. I am constantly amazed at the originality of approach and fresh ideas that Victor manages to get into each of his drawings; the details contained in each merits close attention and study.

In these days of computers and graphics packages, some have questioned the role of the traditional artist working with pencil, paper and watercolours. I have no doubt of its continued importance and relevance. Even the most sophisticated computer graphic illustrations cannot capture the feeling and detail that Victor puts into his pictures. For many his view *is* the view of the past; he enables us to visualise what life must have been like at certain points in the past.

This collection of pictures with their commentaries will therefore form a valuable addition to our views of life in the past. We are again grateful to Victor for making the sometimes dry material of archaeological evidence come back to life in such vibrant works.

Mick Aston

Preface

This book contains a selection of drawings produced on archaeological excavation sites over the past five years. Come rain, come shine I would be drawing in cowsheds, village halls, sitting on old castle walls, standing in rivers but most of the time just out in the open on a plastic chair!

In three days I would follow the archaeology as it came out of the ground and draw the history behind it; I would reconstruct buildings mostly in pencil, because they often needed to be altered as the archaeology changed. Usually I would have an eraser handy to make corrections, while picking the brains of the experts and following the progress in the trenches. My drawings are not only about the buildings but also of the lives of the people who lived there centuries ago; it's lovely to see footprints of a dog or a cat on a roman tile or the fingerprints of a potter put there 1000 years ago. War, murder and mayhem provide dramatic subjects of a different kind and if horses are involved it's even better. For instance, to draw a roman chariot with four horses is a real treat!

I was privileged to meet and work with some of the very best archaeologists in the country and a dedicated team of researchers, historians, technicians, camera crews and production assistants, not forgetting the hard-working diggers. My thanks to Tim Taylor, Mick Aston and Tony Robinson for introducing me to the world of archaeology and to my friends: the *Time Team*.

Victor Ambrus

Acknowledgements

I would like to thank Mick Aston for providing photographs and for helping to edit this book, Tony Robinson for his kind comments, and my son Mark for additional research.

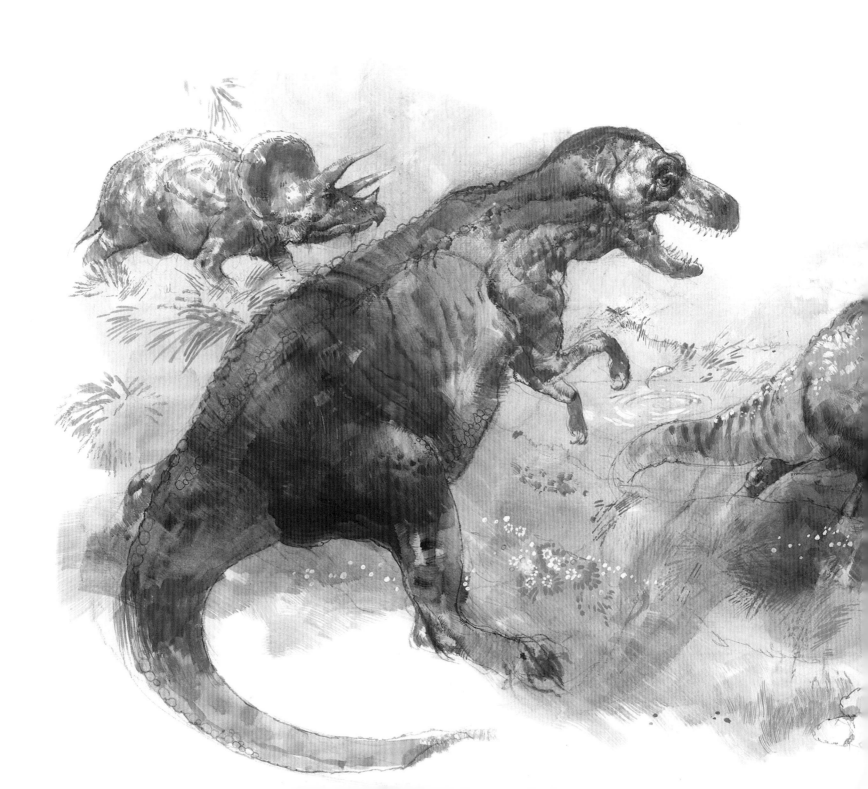

Prehistoric life and animals

A Cretaceous scene in the Badlands, Montana, USA

This picture shows three of the last types of dinosaur to live about 66 million years ago in what is now the Badlands, Montana.

In the foreground the carnivorous Tyrannosaurus is shown striding towards a group of herbivorous Lambeosaurus. In the background on the left is the another herbivore, the Triceratops, while in the foreground are a primitive lizard and early mammal.

As the heads of large carnivorous dinosaurs such as Tyrannosaurus grew larger their front legs grew smaller so that their forequarters remained balanced by their tails. Lambeosaurus had a strange crest that contained nasal passageways which allowed it to make trumpet-like calls to other members of its species. The three horns on the shielded skull of the Triceratops helped it to fend off Tyrannosaurus. Broken horns and bite marks on the skulls of Triceratops testify to this.

Although most dinosaurs did indeed have relatively small brains their bodies functioned more like those of mammals or birds than reptiles. Nevertheless they all appear to have died out about 65 million years ago, perhaps as the result of an asteroid impact off what is now the Yucatan Peninsula, Central America. This allowed the rise of the mammals.

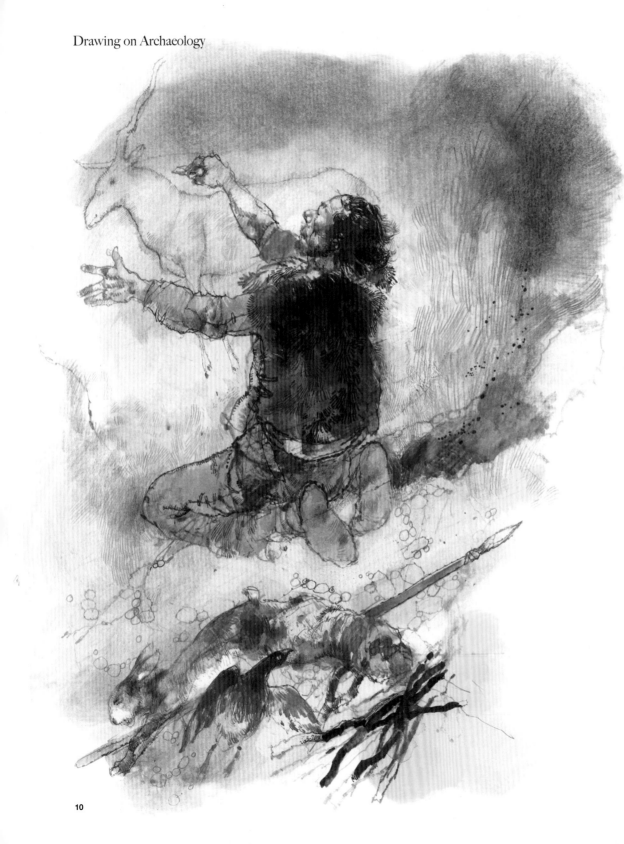

Creswell Crags, Derbyshire

This cave was decorated with remarkable engravings of animals such as stags, wild cattle, brown bears and wading birds that had been carved into the soft stone at the end of the last Ice Age.

It always amazes me how Palaeolithic man was able to produce such sophisticated images of animals that are perfect in movement and proportion and would be difficult to execute by well-trained artists even today. Indeed, their quality is superior to most of the images of animals produced in later and more civilised times.

The arrowhead of Skipsea, Yorkshire

One of our most interesting finds at Skipsea was of a flint arrowhead which inspired this reconstruction of the Mesolithic hunter who might have used it. Arrows may not always have killed an animal outright but they allowed the hunters to catch up with it as it weakened from blood loss and infection.

Small, light and sharp flint artefacts of this type set into wood or bone slots are known as 'microliths'.

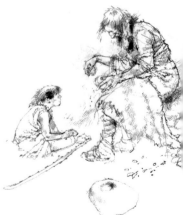

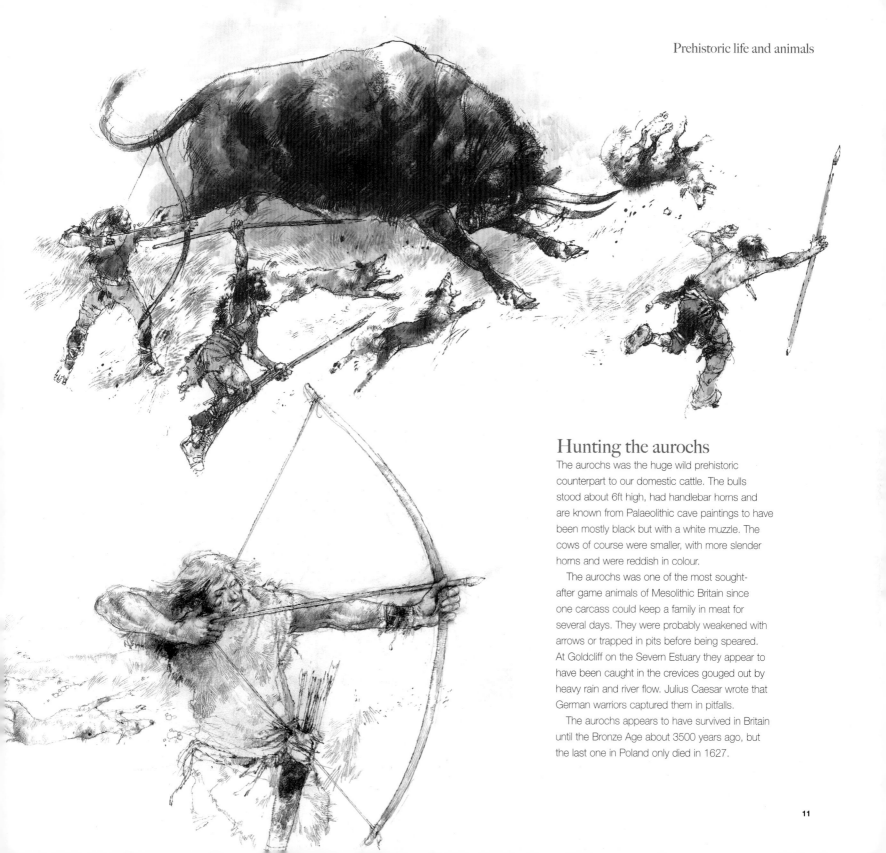

Hunting the aurochs

The aurochs was the huge wild prehistoric counterpart to our domestic cattle. The bulls stood about 6ft high, had handlebar horns and are known from Palaeolithic cave paintings to have been mostly black but with a white muzzle. The cows of course were smaller, with more slender horns and were reddish in colour.

The aurochs was one of the most sought-after game animals of Mesolithic Britain since one carcass could keep a family in meat for several days. They were probably weakened with arrows or trapped in pits before being speared. At Goldcliff on the Severn Estuary they appear to have been caught in the crevices gouged out by heavy rain and river flow. Julius Caesar wrote that German warriors captured them in pitfalls.

The aurochs appears to have survived in Britain until the Bronze Age about 3500 years ago, but the last one in Poland only died in 1627.

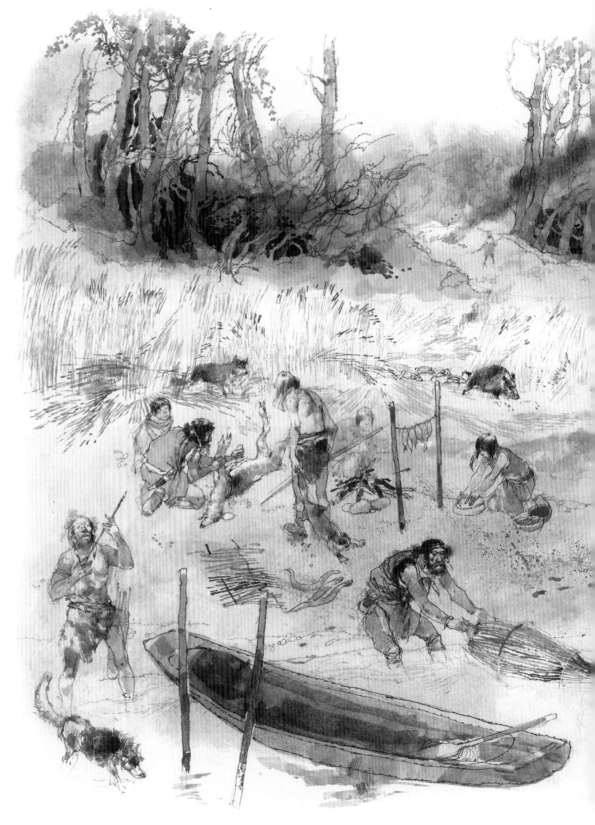

The Severn Estuary at Goldcliff, Monmouthshire

A very unusual form of excavation took place on this Mesolithic site in South Wales. For four hours each day during low tide the archaeologists rushed out onto the clay flats to remove as many square blocks of clay and peat as they could manage, packing them into special steel tins. Back at the field base they spent the rest of the day reassembling the blocks into 1m squares like a jigsaw puzzle and examining them before sieving them for organic remains and artefacts.

This reconstruction shows a Mesolithic family barbecue based on the charcoal, stone-cutting tools and animal and fish bones we found at the site. Charred elderberry and raspberry seeds suggest that this took place in autumn. The remains of a fish trap and a dugout canoe were also recorded from within the vicinity.

Work was also done to analyse the footprints made on the clay banks 8000 years ago. These showed that the children had tried to chase the large European wading birds, called cranes, which were found there. The crevices which had been cut into the clay by heavy rain and river flow provided traps for large animals such as deer, wild boar and the now extinct wild oxen known as aurochs. They were also good for trapping humans, as I found out to my cost while working on this reconstruction!

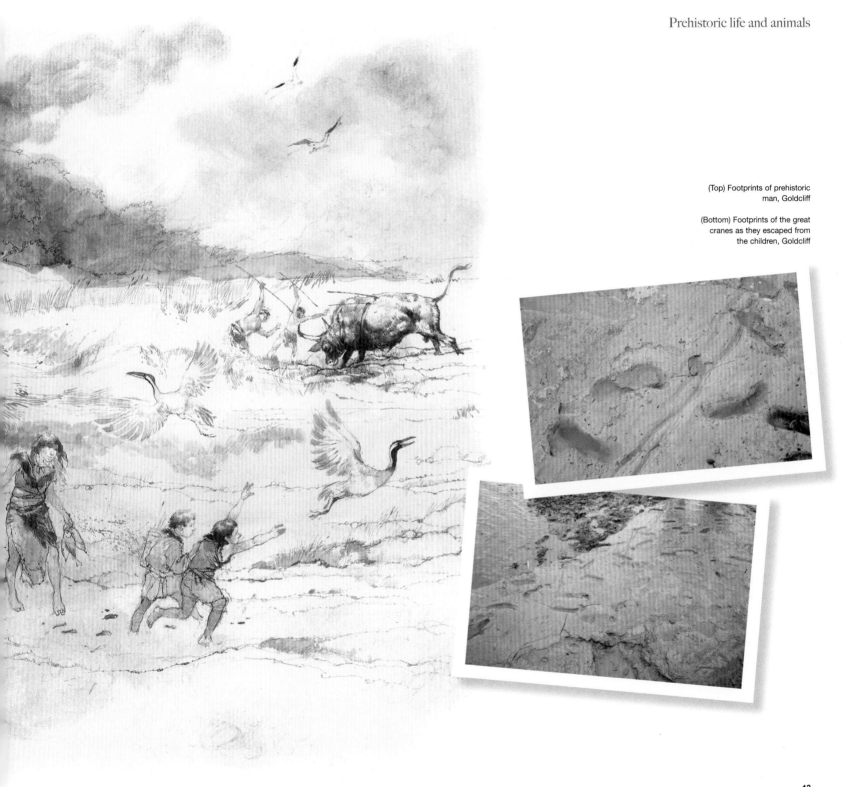

(Top) Footprints of prehistoric man, Goldcliff

(Bottom) Footprints of the great cranes as they escaped from the children, Goldcliff

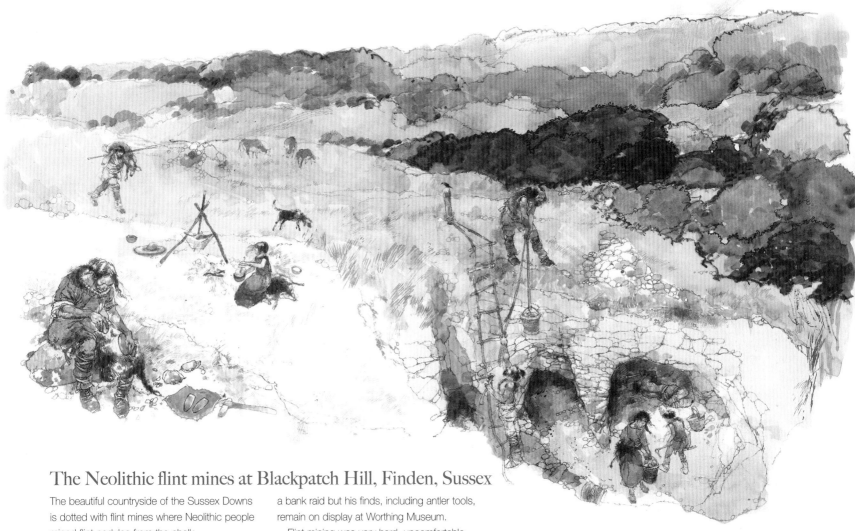

The Neolithic flint mines at Blackpatch Hill, Finden, Sussex

The beautiful countryside of the Sussex Downs is dotted with flint mines where Neolithic people mined flint nodules from the chalk.

John Henry Pull was a local amateur archaeologist who took a job as a postman so that he could spend the rest of the daylight hours excavating the mine galleries around Blackpatch between 1922 and 1932. As he was snubbed by professional archaeologists he could only publish his carefully recorded finds in local newspapers. He was later tragically killed in a bank raid but his finds, including antler tools, remain on display at Worthing Museum.

Flint mining was very hard, uncomfortable and often wet work. Some flint mine galleries were so small and cramped that only women or children could get into them; indeed, a female skeleton was actually found in a nearby gallery. Although there appeared to have been quite enough flint just lying around it seems that the mined flint was of a better quality.

The Neolithic causewayed enclosure at Northborough, Northamptonshire

I made this reconstruction on site of a Neolithic causewayed enclosure on a misty day and added to it as the excavation progressed.

A series of pits had been dug in pairs to form two huge concentric rings broken at points by passage breaks. At one point in the two rings there was a wider entrance break where cattle and sheep might have been driven between hurdles towards the centre for ceremonial slaughter.

By the entrance break there was evidence of feasting as charcoal, animal bones and pottery. There were also splintered bones scattered about which suggested that dead kinsmen had been laid out in American Indian fashion on high platforms until their bodies and then skeletons disintegrated.

Altogether this was a strange and mysterious place that appeared to have served a ritual or ceremonial purpose that we could only speculate upon from ditches, bones and pottery.

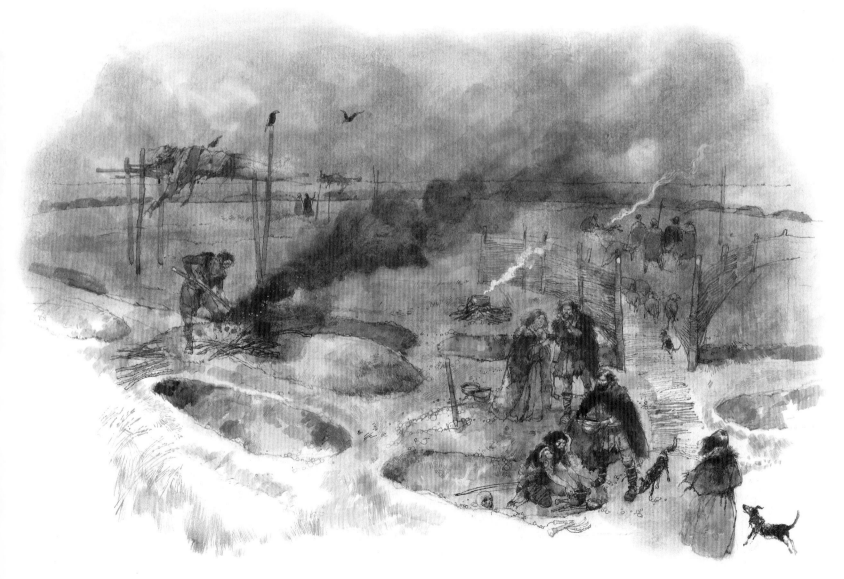

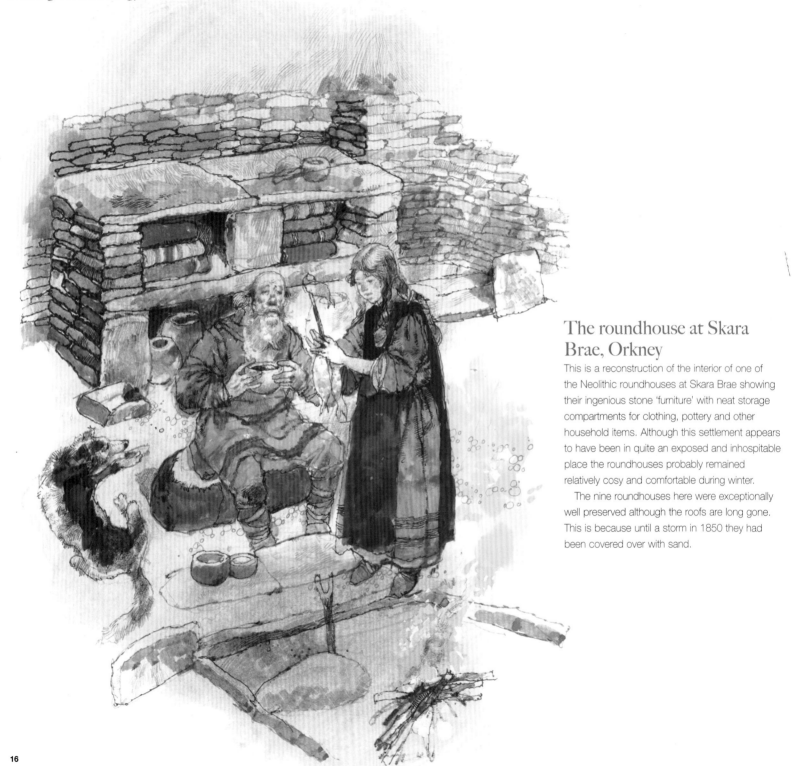

The roundhouse at Skara Brae, Orkney

This is a reconstruction of the interior of one of the Neolithic roundhouses at Skara Brae showing their ingenious stone 'furniture' with neat storage compartments for clothing, pottery and other household items. Although this settlement appears to have been in quite an exposed and inhospitable place the roundhouses probably remained relatively cosy and comfortable during winter.

The nine roundhouses here were exceptionally well preserved although the roofs are long gone. This is because until a storm in 1850 they had been covered over with sand.

Rural life

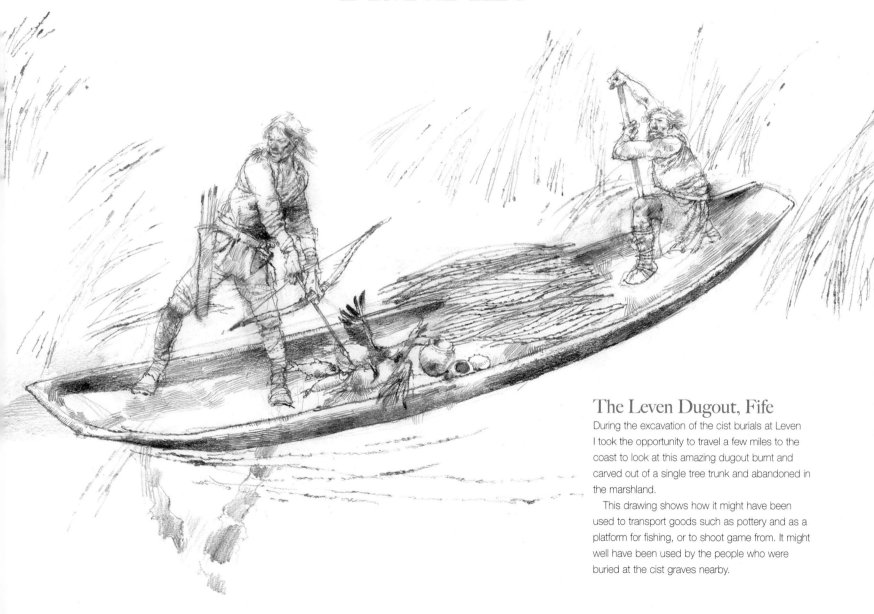

The Leven Dugout, Fife

During the excavation of the cist burials at Leven I took the opportunity to travel a few miles to the coast to look at this amazing dugout burnt and carved out of a single tree trunk and abandoned in the marshland.

This drawing shows how it might have been used to transport goods such as pottery and as a platform for fishing, or to shoot game from. It might well have been used by the people who were buried at the cist graves nearby.

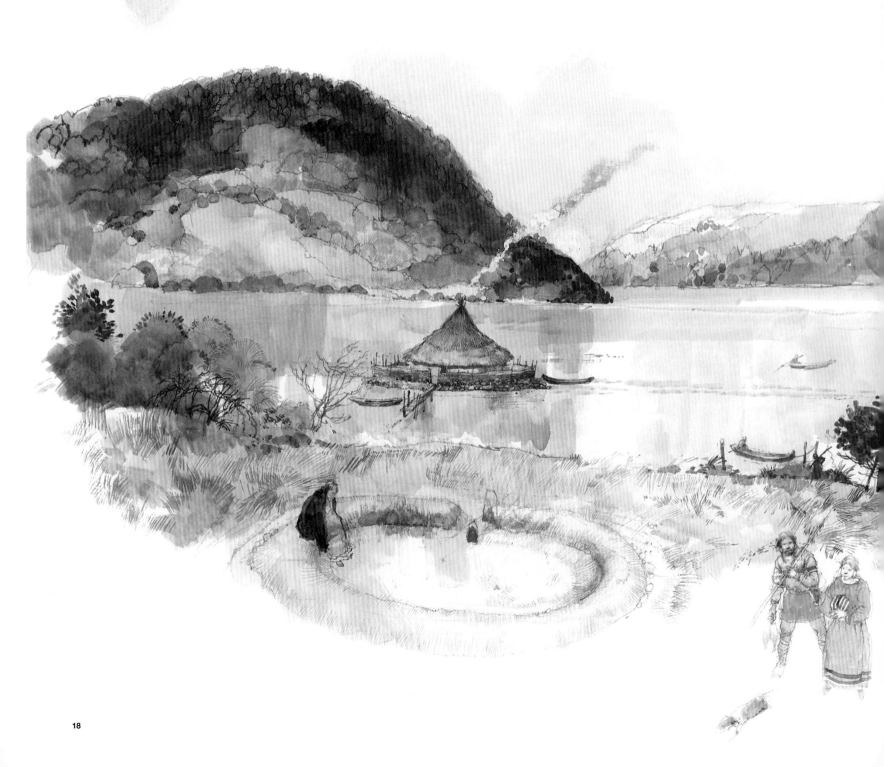

The crannog of Loch Migdale, Sutherland

Migdale Loch is a beautiful place surrounded by pine forests and mountains. In between downpours I managed to paint this reconstruction after tracking my way across the boggy landscape.

Out on the loch was a small man-made island of stones or 'crannog' upon which had stood a roundhouse with timber walls and a thatched roof. It could be approached by either a stone causeway or a boat. It formed a kind of mini fort where a family could feel safe from any surprise attacks by man or beast. It must have been a pleasant place to live with plenty of fish from the loch.

Possible evidence of the prosperity of the same family was provided by the discovery towards the end of the nineteenth century of the Bronze Age 'Migdale Hoard' only a few hundred yards away. These treasures included a bronze axe head and jewellery which could only have belonged to fairly important and wealthy people.

On the shore facing the crannog there was also a Bronze Age cairn or burial mound carefully constructed from peat and white quartz chippings. We excavated it over three days.

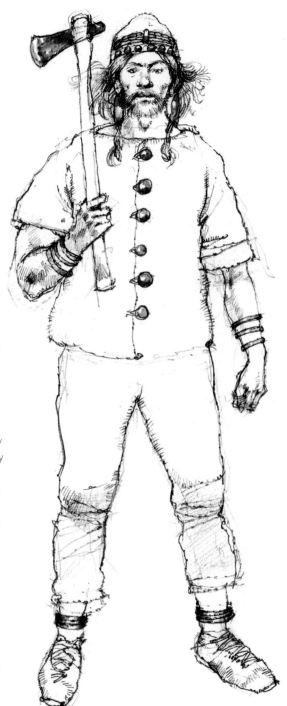

The horse feast at the roundhouse at Standish, Gloucestershire

This is a reconstruction of the remains of an Iron Age roundhouse with an enclosure for animals that we found at Standish.

The finding of the bones of a horse with pottery and charcoal in a section of the perimeter ditch led the archaeologists to request a second drawing of a horse feast. It appears that at the time the old roundhouse was pulled down the family and their friends gathered together to eat the horse by the entrance. The bones and leftovers were then pushed into the perimeter ditch.

Instead of being a 'house warming' party this was evidently a 'house leaving' party.

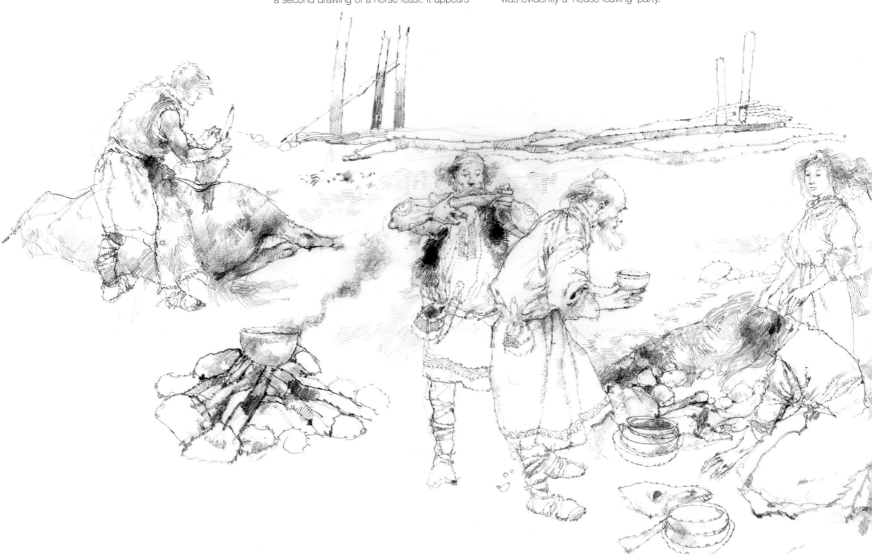

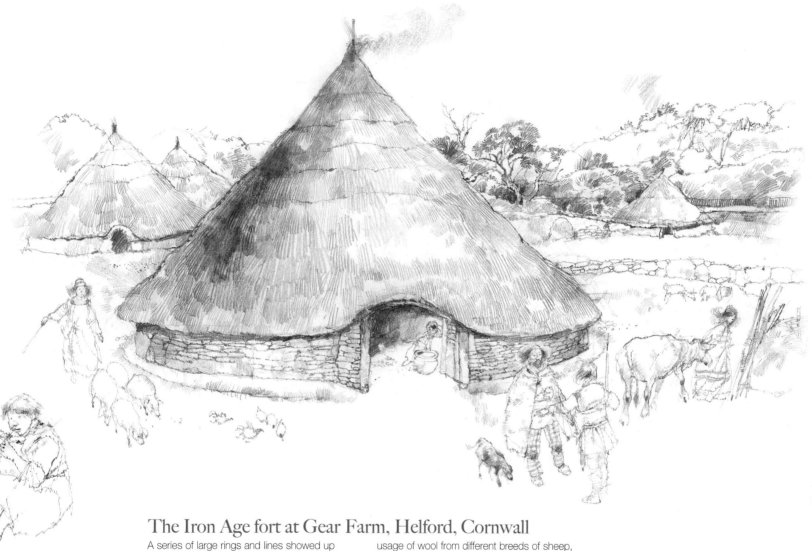

The Iron Age fort at Gear Farm, Helford, Cornwall

A series of large rings and lines showed up here on the geophysics printout. Excavations uncovered the remains of several Iron Age roundhouses with walled animal enclosures. These had been surrounded by a formidable earth bank surmounted by a timber palisade and overlooking a very deep ditch.

The 'tartan' patterned weave cloth worn by people of the Iron Age probably arose from the usage of wool from different breeds of sheep, some with black fleeces and others with lighter tan tones.

The life of the inhabitants appears to have been relatively peaceful. During the day they worked the fields and tended to the animals while at night they slept in their roundhouses with their animals enclosed outside; secure behind their wooden and earthen defences.

Iron Age settlement near
Throckmorton

Iron Age settlement near Throckmorton, Worcestershire

The geophysical data taken at the now largely disused RAF airbase at Throckmorton in Worcestershire revealed a thriving late Bronze Age and Iron Age settlement. Several enclosures were found to be present linked together by pathways. Each enclosure was ringed by a ditch with a gateway and contained roundhouses and compounds for animals at night.

This data allowed me to make an exciting bird's-eye view of the settlement. The day I drew this picture the last carcasses of cows killed to prevent the spread of the 'foot and mouth' disease epidemic of 2001 were being burnt. Consequently an ominous black cloud hung over what must have once been pleasant ancient fields.

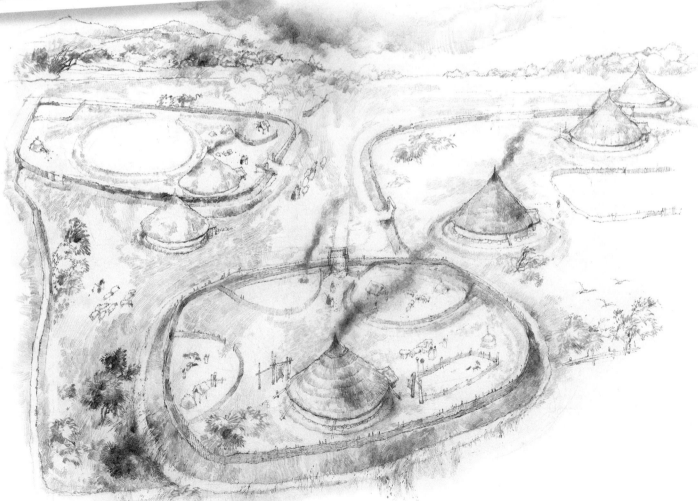

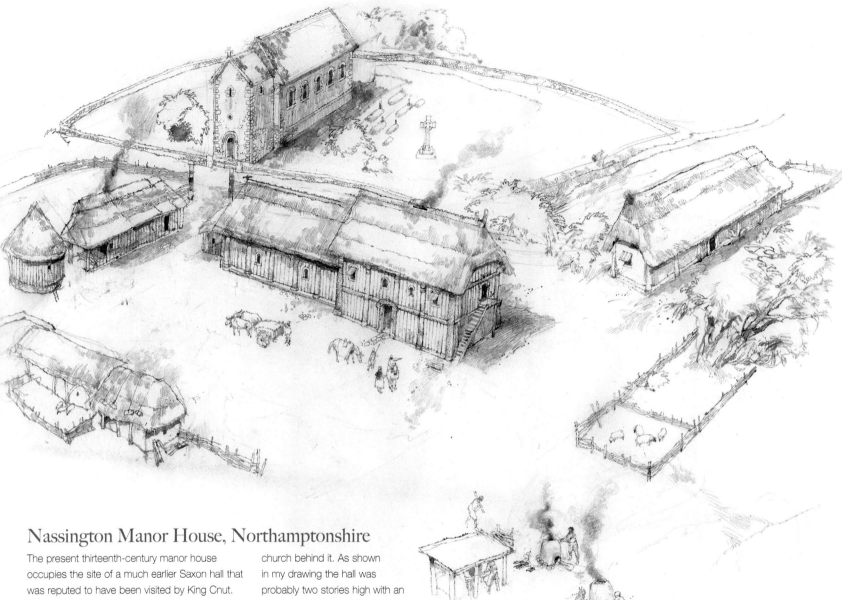

Nassington Manor House, Northamptonshire

The present thirteenth-century manor house occupies the site of a much earlier Saxon hall that was reputed to have been visited by King Cnut.

After considerable effort was spent lifting up the old flagstones of the floor of the present manor house we found the postholes that would have supported the timbered columns of the original Saxon hall. From these I was able to make a rough reconstruction of the size and shape of the building as well as of the tall and narrow Saxon church behind it. As shown in my drawing the hall was probably two stories high with an outside staircase.

Landscaping appeared to have removed any traces of the surrounding buildings but these may have included a dovecote, stable block, kilns, workshops and animal pens. A few fragments of pottery were found, however, that dated from the time of King Cnut.

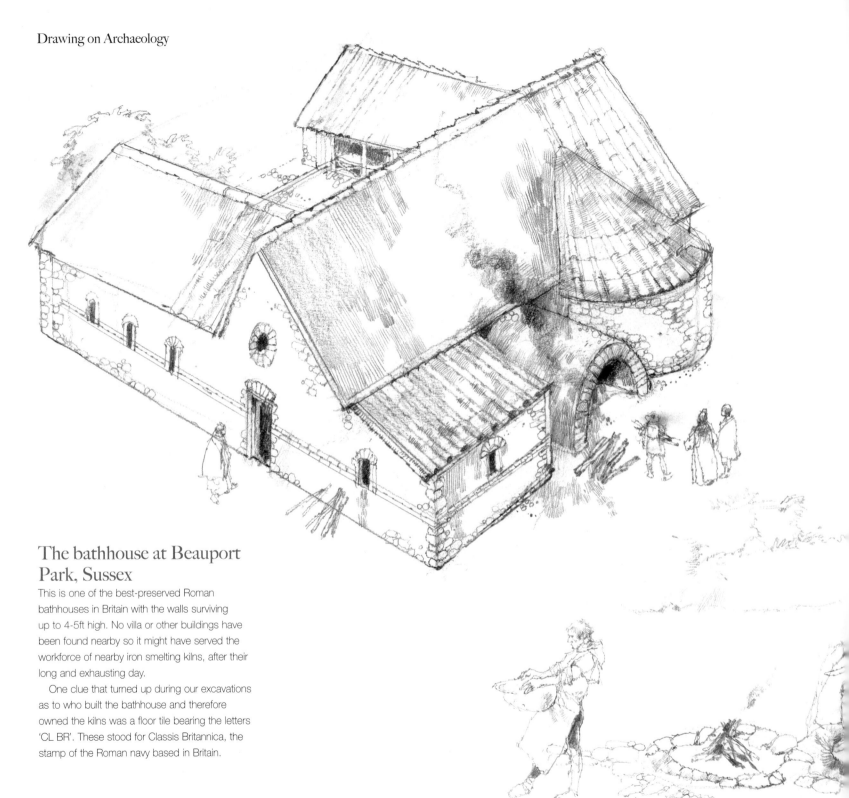

The bathhouse at Beauport Park, Sussex

This is one of the best-preserved Roman bathhouses in Britain with the walls surviving up to 4-5ft high. No villa or other buildings have been found nearby so it might have served the workforce of nearby iron smelting kilns, after their long and exhausting day.

One clue that turned up during our excavations as to who built the bathhouse and therefore owned the kilns was a floor tile bearing the letters 'CL BR'. These stood for Classis Britannica, the stamp of the Roman navy based in Britain.

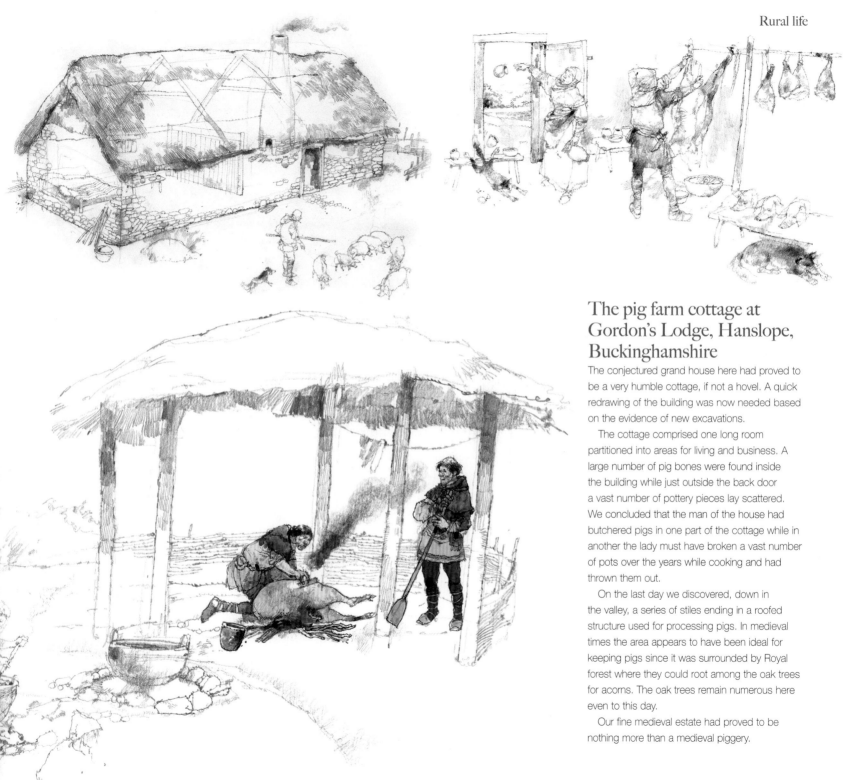

The pig farm cottage at Gordon's Lodge, Hanslope, Buckinghamshire

The conjectured grand house here had proved to be a very humble cottage, if not a hovel. A quick redrawing of the building was now needed based on the evidence of new excavations.

The cottage comprised one long room partitioned into areas for living and business. A large number of pig bones were found inside the building while just outside the back door a vast number of pottery pieces lay scattered. We concluded that the man of the house had butchered pigs in one part of the cottage while in another the lady must have broken a vast number of pots over the years while cooking and had thrown them out.

On the last day we discovered, down in the valley, a series of stiles ending in a roofed structure used for processing pigs. In medieval times the area appears to have been ideal for keeping pigs since it was surrounded by Royal forest where they could root among the oak trees for acorns. The oak trees remain numerous here even to this day.

Our fine medieval estate had proved to be nothing more than a medieval piggery.

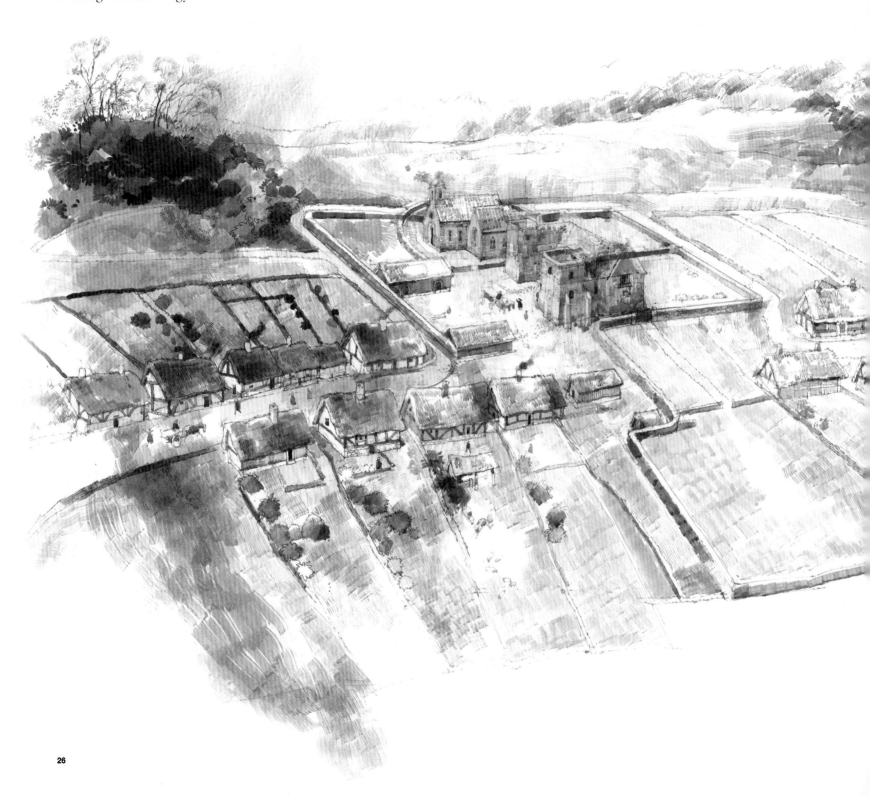

Henderskelfe village, Yorkshire

The name 'Henderskelfe' suggests that it was originally a Viking settlement. A small castle and church were added to it during medieval times.

This small village was totally obliterated when the vast Castle Howard was built over it in the early eighteenth century. The site had been so efficiently cleared that the excavations produced next to no evidence of the original half-timbered buildings. The timbers were probably reused and the stones from the castle and the church became hardcore for the grand new house.

We did however find a lovely old map among the papers in the library of Castle Howard which gave the exact location of every building so that I could reconstruct how Henderskelfe must have looked. We also found a list of the families who lived there – and their criminal records!

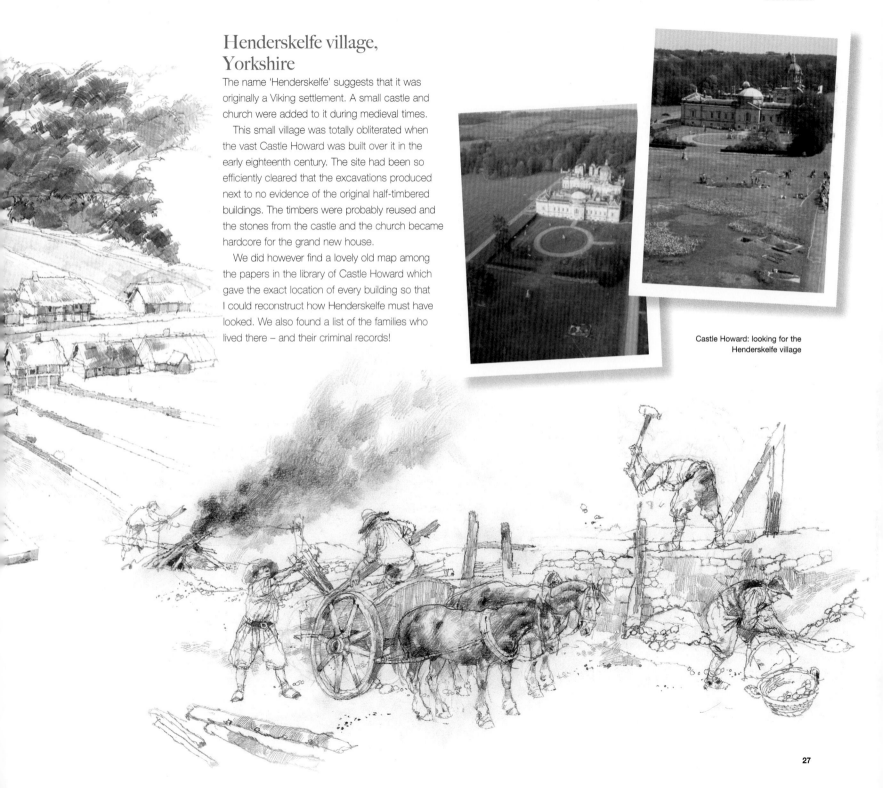

Castle Howard: looking for the Henderskelfe village

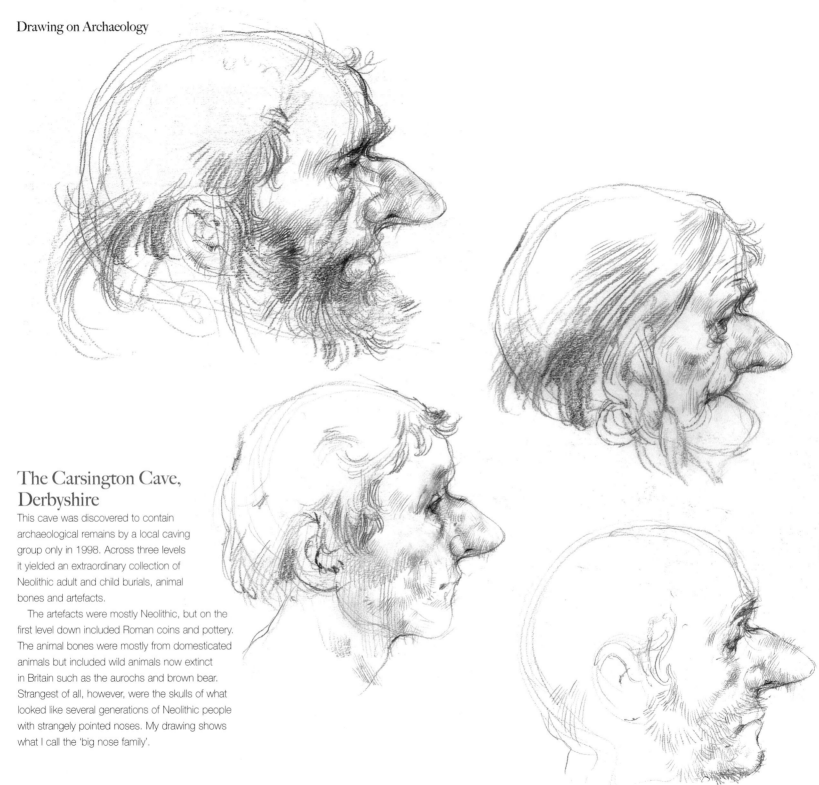

The Carsington Cave, Derbyshire

This cave was discovered to contain archaeological remains by a local caving group only in 1998. Across three levels it yielded an extraordinary collection of Neolithic adult and child burials, animal bones and artefacts.

The artefacts were mostly Neolithic, but on the first level down included Roman coins and pottery. The animal bones were mostly from domesticated animals but included wild animals now extinct in Britain such as the aurochs and brown bear. Strangest of all, however, were the skulls of what looked like several generations of Neolithic people with strangely pointed noses. My drawing shows what I call the 'big nose family'.

Burials, rituals and religions

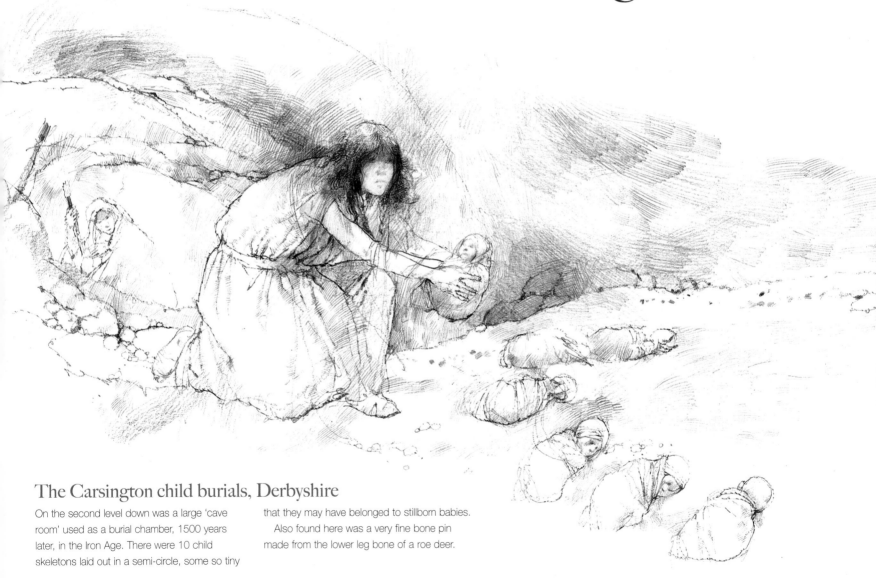

The Carsington child burials, Derbyshire

On the second level down was a large 'cave room' used as a burial chamber, 1500 years later, in the Iron Age. There were 10 child skeletons laid out in a semi-circle, some so tiny that they may have belonged to stillborn babies.

Also found here was a very fine bone pin made from the lower leg bone of a roe deer.

Reconstructing a timber circle at Durrington Walls, Wiltshire

The vast Neolithic ditch-enclosed area or henge at Durrington Walls is the largest in Britain with a diameter of nearly 500m. Excavations have shown that timber posts up to over 2m wide once stood in two separate circular areas within it.

The erection of these posts would have required a large communal effort which probably involved hoisting them up with A-frames as shown here. The finished structure may have had a roof and looked like a primitive cathedral which was almost certainly used for ceremony and sacrifice.

The processional pathway from the henge down to the River Avon would have been prepared by everyone, including youngsters, working hard using antler picks to dislodge chalk from beneath the topsoil. There were several Neolithic huts in the vicinity of the henge at Durrington Walls where charcoal and pig bones suggested feasting. The average Neolithic hut comprised of a small hollow surrounded by a low stone wall with an animal skin or thatched roof. The pigs would have been kept within adjoining enclosures and looked more like miniature wild boars than the large, fat and relatively hairless pigs that we have today.

Archaeologists believe that the henge had something to do with the journey of the soul in the afterlife downriver to nearby Stonehenge. It seems that Neolithic people evidently came here to see off or remember dead relatives amid ceremonies and feasting.

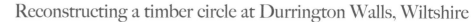

Neolithic long barrow at South Perrott, Dorset

The large number of Roman coins we found at this site led us to believe that we were looking at a Roman temple site. As the excavation progressed, however, we realised that this was actually part of the circuit ditch of a much earlier, oval-shaped, Neolithic long barrow where the Romans had continued to make offerings many centuries later.

These barrows appear to have been surrounded by wooden posts to enclose platforms where bodies were laid out, exposed to the elements. It is because bodies were left as open burials or 'excarnations' rather than buried during the Neolithic period that we find very few human remains from these times, only fragments of bones scattered around where the platforms were.

This reconstruction was worked over several times as more evidence came to light until it was left depicting the earliest Neolithic stage of the site.

Section of the long barrow at
South Perrot, Dorset

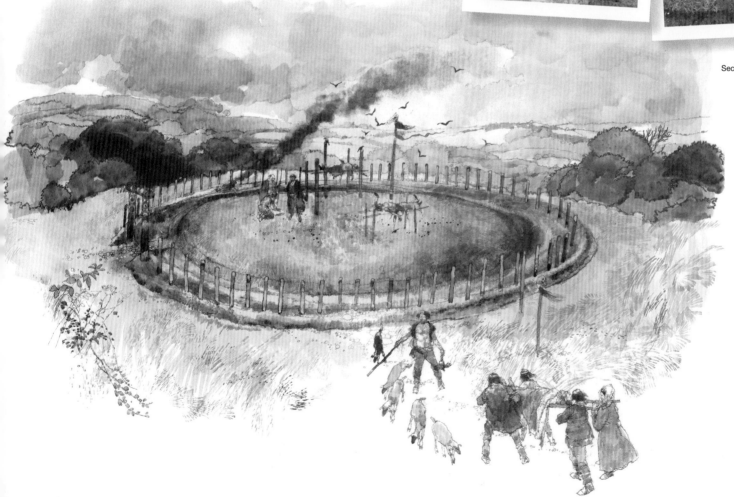

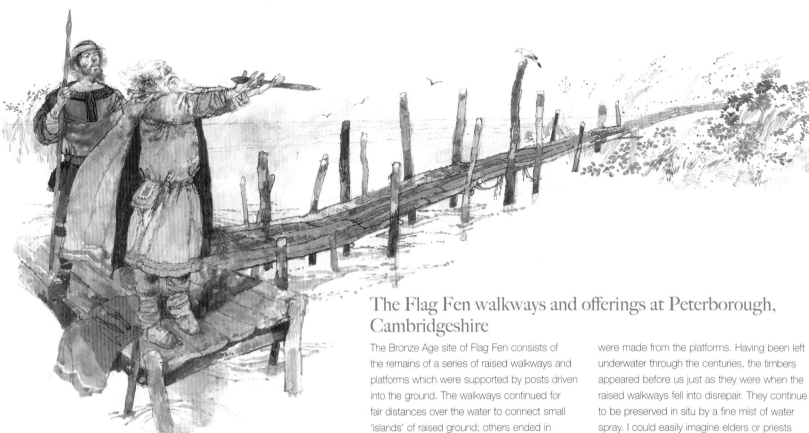

The Flag Fen walkways and offerings at Peterborough, Cambridgeshire

The Bronze Age site of Flag Fen consists of the remains of a series of raised walkways and platforms which were supported by posts driven into the ground. The walkways continued for fair distances over the water to connect small 'islands' of raised ground; others ended in platforms.

The discovery of numerous bronze artefacts such as axe heads and swords suggests that Flag Fen was a sacred site where offerings were made from the platforms. Having been left underwater through the centuries, the timbers appeared before us just as they were when the raised walkways fell into disrepair. They continue to be preserved in situ by a fine mist of water spray. I could easily imagine elders or priests making offerings from the platforms or using the raised walkways to reach pleasant islands covered with lush bushes and flowering shrubs.

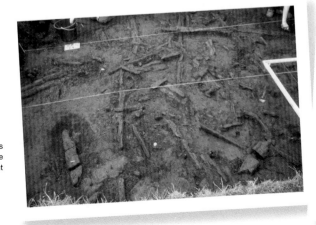

Walkways and timber sections exposed at Flag Fen Bronze Age settlement

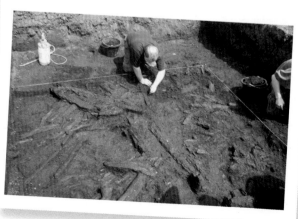

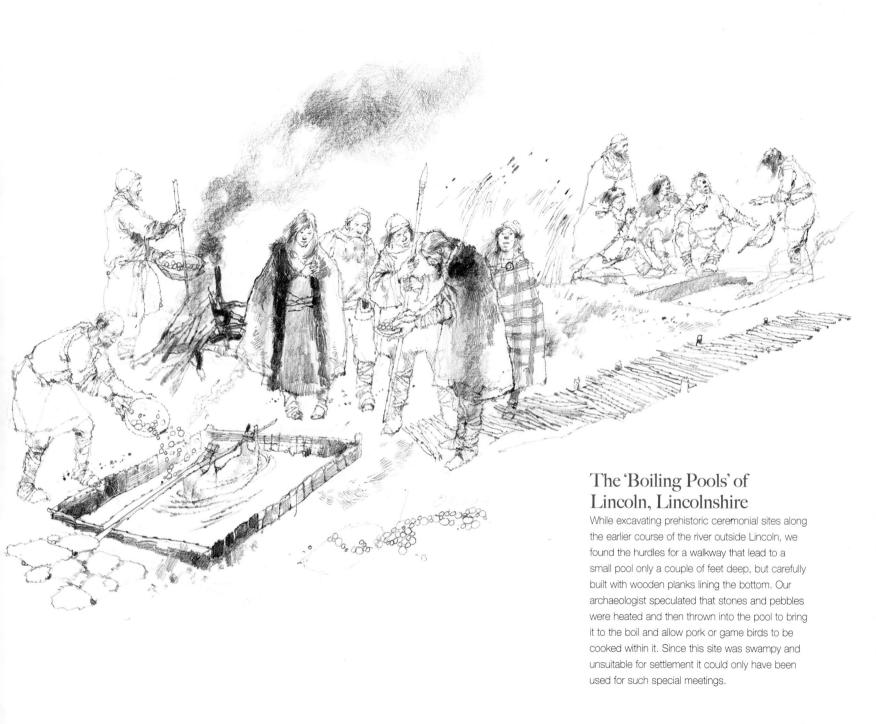

The 'Boiling Pools' of Lincoln, Lincolnshire

While excavating prehistoric ceremonial sites along the earlier course of the river outside Lincoln, we found the hurdles for a walkway that lead to a small pool only a couple of feet deep, but carefully built with wooden planks lining the bottom. Our archaeologist speculated that stones and pebbles were heated and then thrown into the pool to bring it to the boil and allow pork or game birds to be cooked within it. Since this site was swampy and unsuitable for settlement it could only have been used for such special meetings.

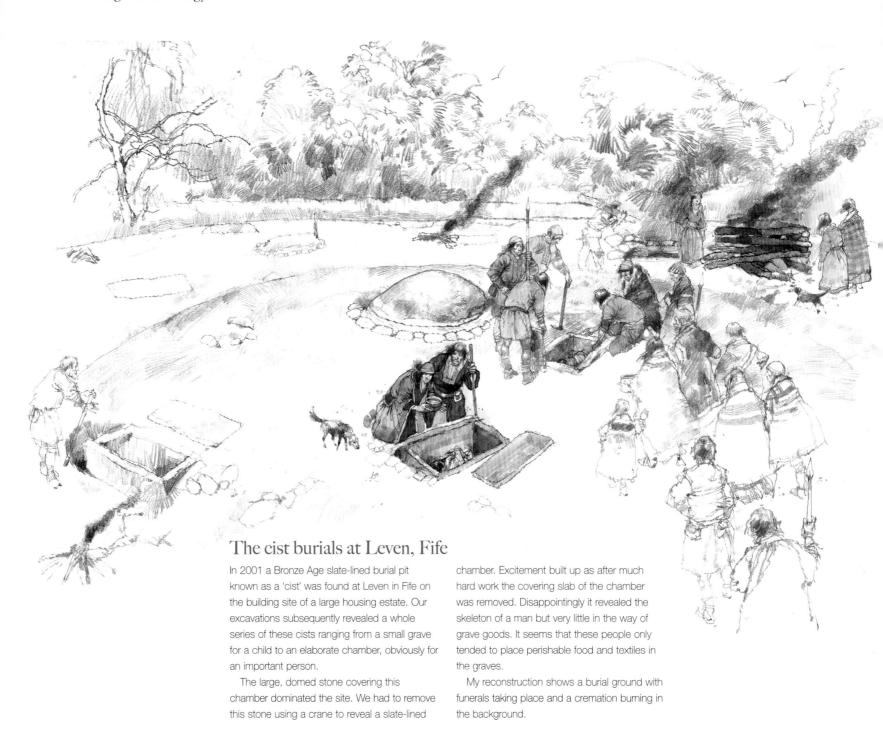

The cist burials at Leven, Fife

In 2001 a Bronze Age slate-lined burial pit known as a 'cist' was found at Leven in Fife on the building site of a large housing estate. Our excavations subsequently revealed a whole series of these cists ranging from a small grave for a child to an elaborate chamber, obviously for an important person.

The large, domed stone covering this chamber dominated the site. We had to remove this stone using a crane to reveal a slate-lined chamber. Excitement built up as after much hard work the covering slab of the chamber was removed. Disappointingly it revealed the skeleton of a man but very little in the way of grave goods. It seems that these people only tended to place perishable food and textiles in the graves.

My reconstruction shows a burial ground with funerals taking place and a cremation burning in the background.

The family of rats inside the skull at Leven, Fife

One bizarre aspect of this burial was that some time after it took place a rat appears to have entered the chamber and made a nest for her family of young inside the man's skull. We know this because as they grew up they sharpened their teeth on the inner surface of the skull.

This must have been the final indignity for someone who, from his careful interment, might have been a tribal elder or even a chieftain.

The cist burials of a woman and a child complete with grave goods.

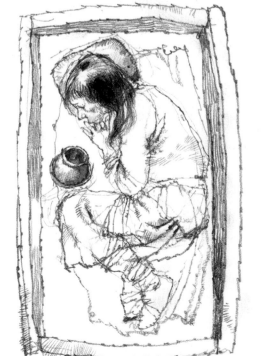

Wittenham Clumps, Little Wittenham, Oxfordshire

In his account of the Roman wars against the Gauls in what is now France, Julius Caesar vividly described the human sacrifices practised by the Celtic priests known as Druids.

One of the Wittenham hills had an extensive Iron Age fort constructed on it. The other slightly taller and more perfectly formed hill, however, only ever appears to have had a clump of trees on it – hence the name Wittenham Clumps. As this hill had no archaeological remains on it the chances are that it was used for ritual purposes, perhaps human sacrifice. This drawing is based on the assumption that the Druids practised the same rituals here as their counterparts across the Channel.

Wittenham Clumps must have been surrounded since Iron Age times by farms, fields and roundhouses as well as the large fort and yet it was left to loom over this landscape untouched by human development.

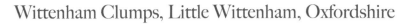

The Roman temple at Ancaster, Lincolnshire

A tablet found in the church grounds of Ancaster several years ago appears to have been placed over the arch leading to a Roman temple dedicated to a god named 'Viridio'. This was surmised from the inscription on it which roughly translates as 'Trenco built this arch to the God Viridios with his own money'.

This drawing shows offerings being placed on the stone altar in front of the temple with goats and other animals being led forward for sacrifice. Buying and selling is going on in front of the temple, an activity usually indicated to the archaeologists by the discovery of a large number of coins.

During our excavation of the nearby Roman cemetery we found another stone that referred to this god within the stone-lined burial or cist of an elderly man. The stone might have been inscribed for him as a worshipper of the god, or it might have been taken from the temple itself.

These references to a Roman god named Viridios are unique; it seems likely that he was derived from an earlier Celtic god of the verdure, or forests.

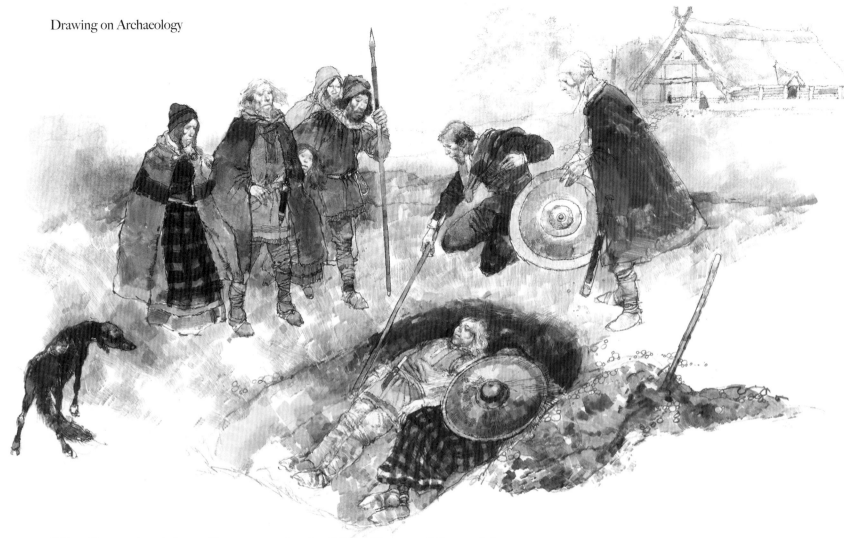

The Saxon burials at Braemore in the New Forest, Hampshire

We excavated this extraordinary Saxon burial site in the New Forest after a metal detectorist had discovered a Byzantine bronze and silver bucket on the site.

Two or three skeletons were found together within each burial and they appear to have belonged to quite important people. As well as every skeleton being covered by a shield and having a spear alongside, nearly every burial contained a wooden bucket reinforced with copper bands, along with knives, tweezers, buckles and beads. One of the six buckets even contained a unique pale green glass bowl that had probably been imported from the Rhineland. Each bucket would have contained some kind of food or drink for consumption in the afterlife. Many of these finds are on view at the Winchester Museum.

How all these people came to die at the same time and place is a mystery. Their skeletons showed no signs of wounding or injury and the shield bosses showed no signs of cuts or dents. This suggests that the weapons might have been more of symbolic importance to them than practical use.

This reconstruction shows the burial as it might have happened of a middle-aged man and woman with the woman facing him. Another burial contained the skeletons of an older and younger man facing each other with a very young child in between.

When a new burial was found I got a call from Mel the Director: 'Two skeletons in Phil's trench – bring them alive'. I thought: I can draw them but I can't perform miracles.

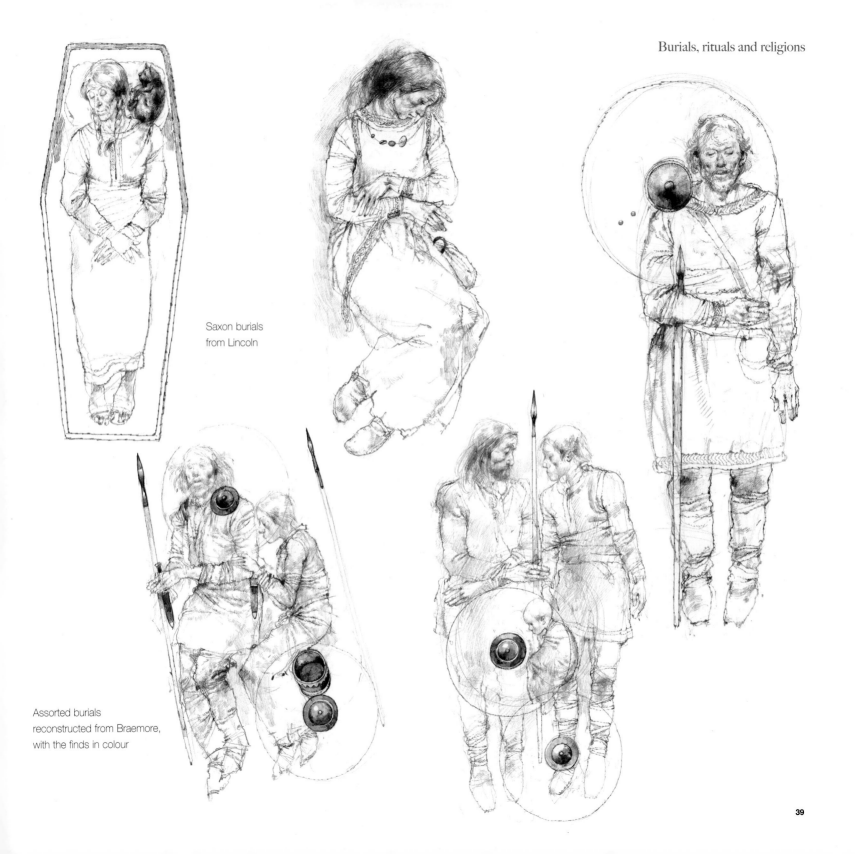

Saxon burials
from Lincoln

Assorted burials
reconstructed from Braemore,
with the finds in colour

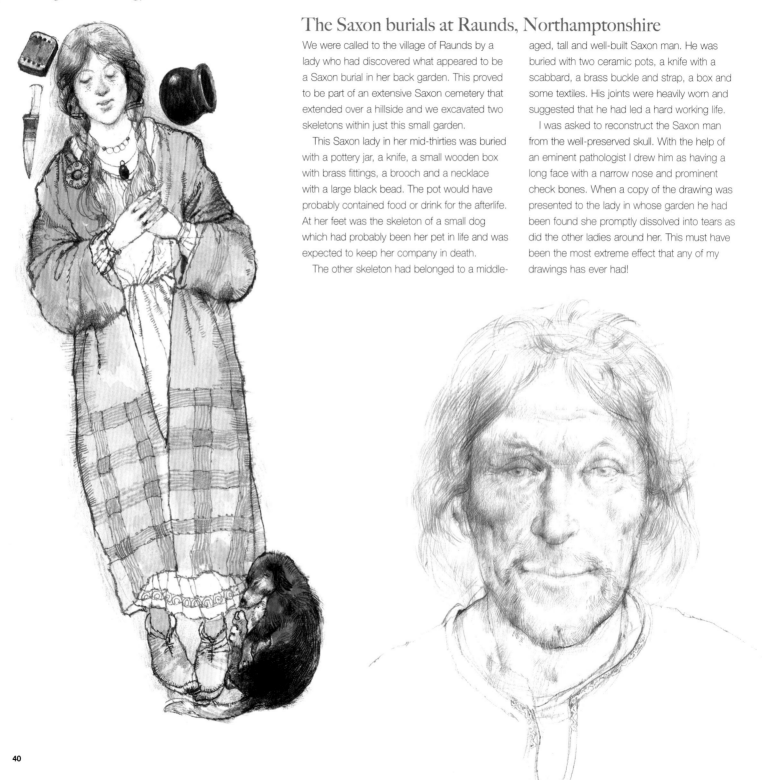

The Saxon burials at Raunds, Northamptonshire

We were called to the village of Raunds by a lady who had discovered what appeared to be a Saxon burial in her back garden. This proved to be part of an extensive Saxon cemetery that extended over a hillside and we excavated two skeletons within just this small garden.

This Saxon lady in her mid-thirties was buried with a pottery jar, a knife, a small wooden box with brass fittings, a brooch and a necklace with a large black bead. The pot would have probably contained food or drink for the afterlife. At her feet was the skeleton of a small dog which had probably been her pet in life and was expected to keep her company in death.

The other skeleton had belonged to a middle-aged, tall and well-built Saxon man. He was buried with two ceramic pots, a knife with a scabbard, a brass buckle and strap, a box and some textiles. His joints were heavily worn and suggested that he had led a hard working life.

I was asked to reconstruct the Saxon man from the well-preserved skull. With the help of an eminent pathologist I drew him as having a long face with a narrow nose and prominent check bones. When a copy of the drawing was presented to the lady in whose garden he had been found she promptly dissolved into tears as did the other ladies around her. This must have been the most extreme effect that any of my drawings has ever had!

The drinker of South Carlton, Lincolnshire

While excavating a large field at South Carlton just outside Lincoln we found the skeleton of an elderly man beneath a large heavy stone who was hugging a very large pottery jar which must have contained some sort of liquid refreshment.

We could not be sure of the significance of the stone but the man had obviously enjoyed a few drinks during his lifetime. Our archaeologists concluded that he might have been the village drunk and invited me to draw him knocking back the contents of his large jar.

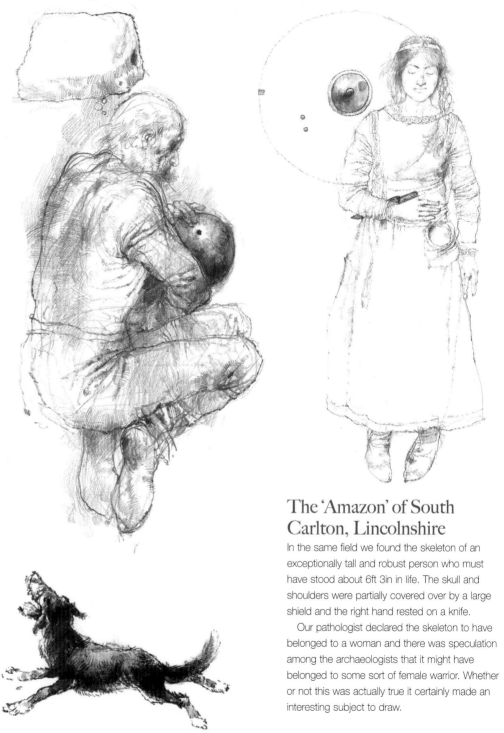

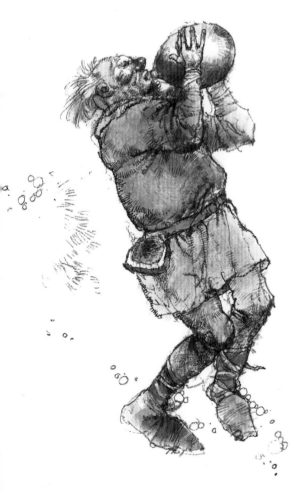

The 'Amazon' of South Carlton, Lincolnshire

In the same field we found the skeleton of an exceptionally tall and robust person who must have stood about 6ft 3in in life. The skull and shoulders were partially covered over by a large shield and the right hand rested on a knife.

Our pathologist declared the skeleton to have belonged to a woman and there was speculation among the archaeologists that it might have belonged to some sort of female warrior. Whether or not this was actually true it certainly made an interesting subject to draw.

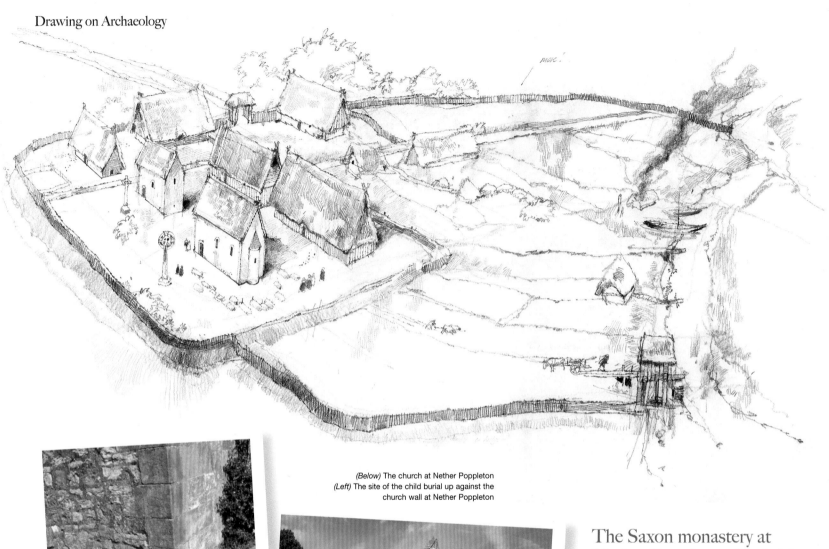

(Below) The church at Nether Poppleton
(Left) The site of the child burial up against the church wall at Nether Poppleton

The Saxon monastery at Nether Poppleton, Yorkshire

Nether Poppleton was referred to as the land of St Everilda in *Domesday Book* and it is likely that a Saxon monastery was established here.

Our excavations suggested that two churches, some small but solidly built buildings and several outhouses and farm buildings were present. The churches would have had no spires but standing crosses would have marked them out as holy buildings.

A walled enclosure led down to the river where there may have been a small water mill.

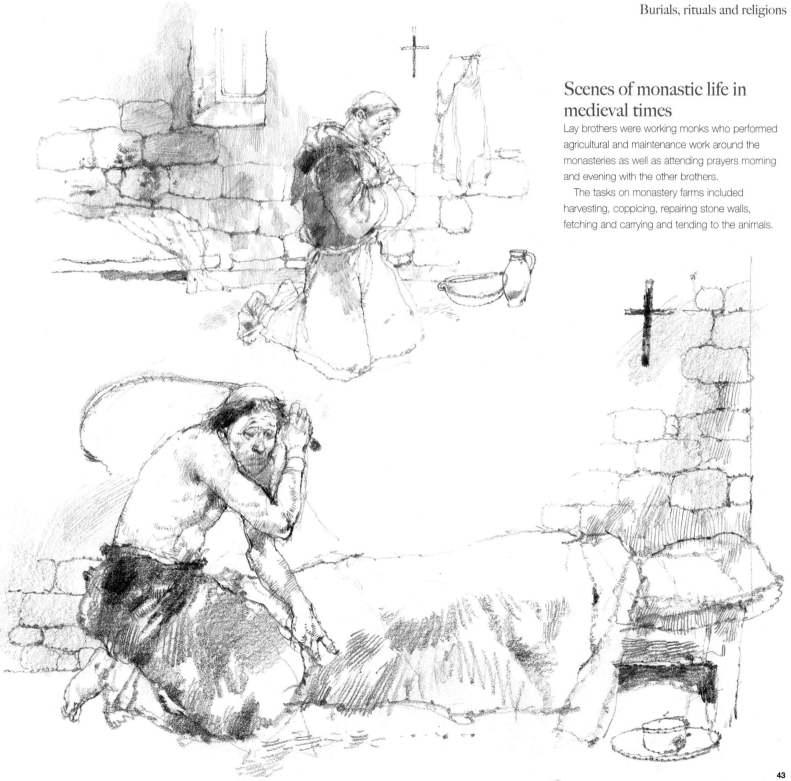

Scenes of monastic life in medieval times

Lay brothers were working monks who performed agricultural and maintenance work around the monasteries as well as attending prayers morning and evening with the other brothers.

The tasks on monastery farms included harvesting, coppicing, repairing stone walls, fetching and carrying and tending to the animals.

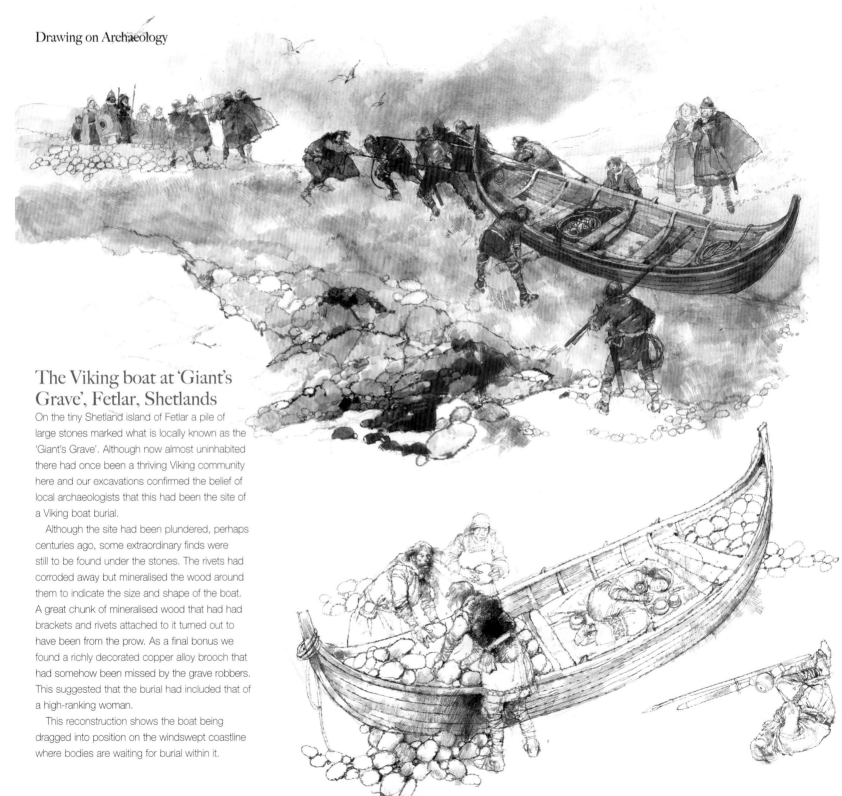

The Viking boat at 'Giant's Grave', Fetlar, Shetlands

On the tiny Shetland island of Fetlar a pile of large stones marked what is locally known as the 'Giant's Grave'. Although now almost uninhabited there had once been a thriving Viking community here and our excavations confirmed the belief of local archaeologists that this had been the site of a Viking boat burial.

Although the site had been plundered, perhaps centuries ago, some extraordinary finds were still to be found under the stones. The rivets had corroded away but mineralised the wood around them to indicate the size and shape of the boat. A great chunk of mineralised wood that had had brackets and rivets attached to it turned out to have been from the prow. As a final bonus we found a richly decorated copper alloy brooch that had somehow been missed by the grave robbers. This suggested that the burial had included that of a high-ranking woman.

This reconstruction shows the boat being dragged into position on the windswept coastline where bodies are waiting for burial within it.

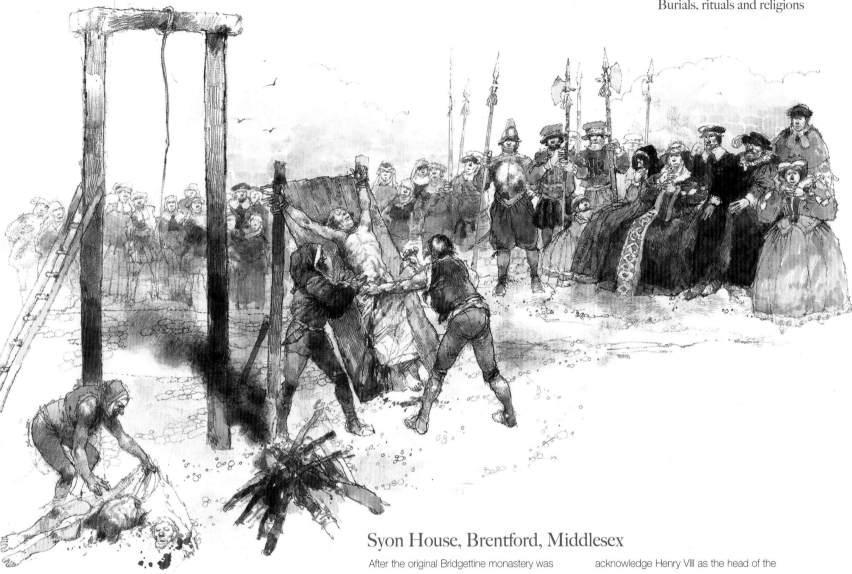

The Viking boat burial, Fetlar, Shetlands

In this second drawing I have shown two bodies laid in crouching position within the boat as the archaeologists thought that there might have been a male burial here as well, quite possibly that of the woman's husband.

Syon House, Brentford, Middlesex

After the original Bridgettine monastery was sacked and looted in 1539 on the orders of Henry VIII during the dissolution of the monasteries, one stone pediment from the gateway was carried away by the Bridgettine nuns. The beautifully carved gothic stonework is still looked after to this day by the nuns at Syon Abbey, South Brent, in Devon. It is said to have been stained by the blood of Richard Reynolds, the Abbot of Syon Abbey.

Richard Reynolds had refused to acknowledge Henry VIII as the head of the Church so Henry had him hung, drawn and quartered along with some of the other priests at Tyburn on 4 May 1535. Members of the royal court gloated over and even assisted in the ghastly executions and Henry himself was said to have been present among the crowd. If this drawing is repulsive then the actual event must have been far worse. Richard Reynolds was by all accounts a decent and pious priest who died a horrible death for his beliefs.

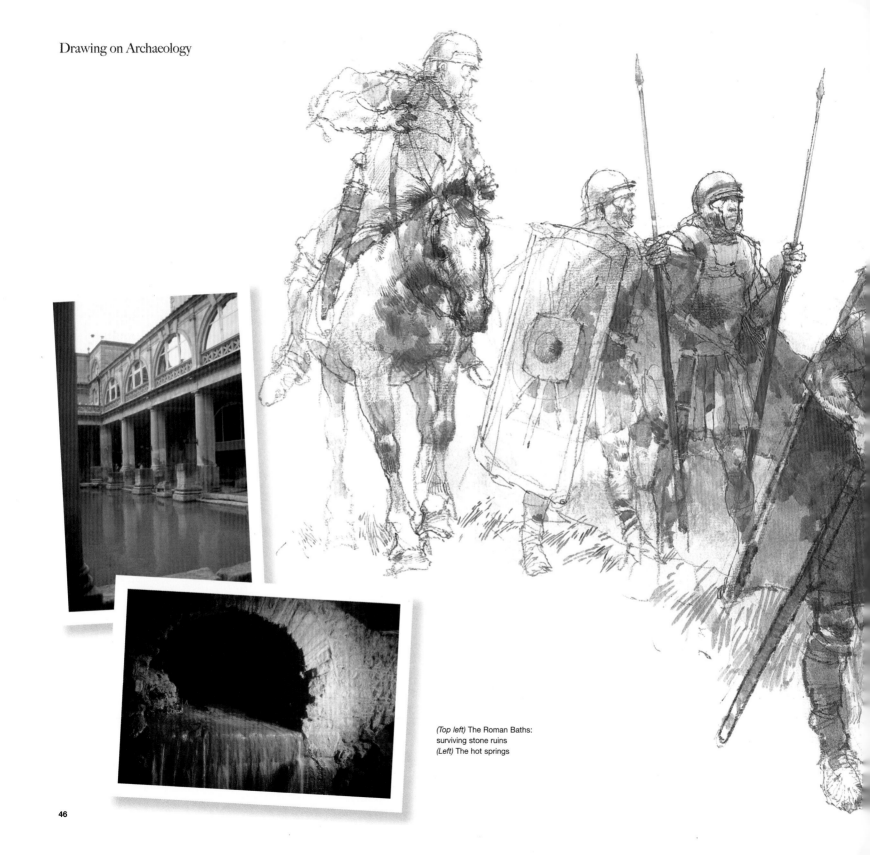

(Top left) The Roman Baths:
surviving stone ruins
(Left) The hot springs

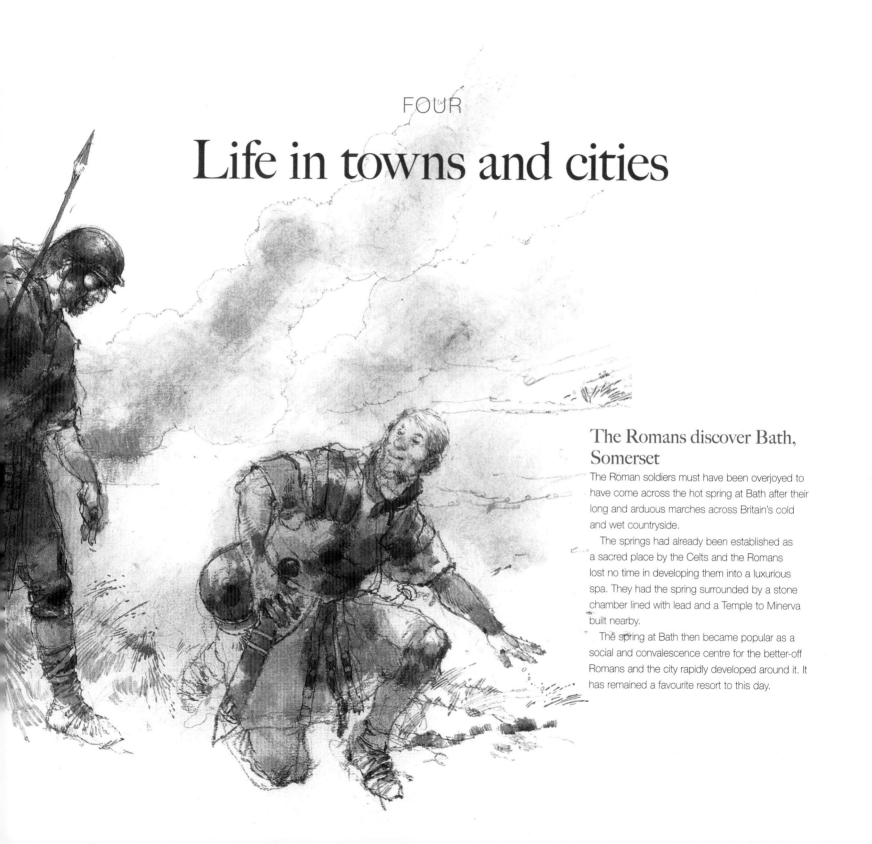

Life in towns and cities

The Romans discover Bath, Somerset

The Roman soldiers must have been overjoyed to have come across the hot spring at Bath after their long and arduous marches across Britain's cold and wet countryside.

The springs had already been established as a sacred place by the Celts and the Romans lost no time in developing them into a luxurious spa. They had the spring surrounded by a stone chamber lined with lead and a Temple to Minerva built nearby.

The spring at Bath then became popular as a social and convalescence centre for the better-off Romans and the city rapidly developed around it. It has remained a favourite resort to this day.

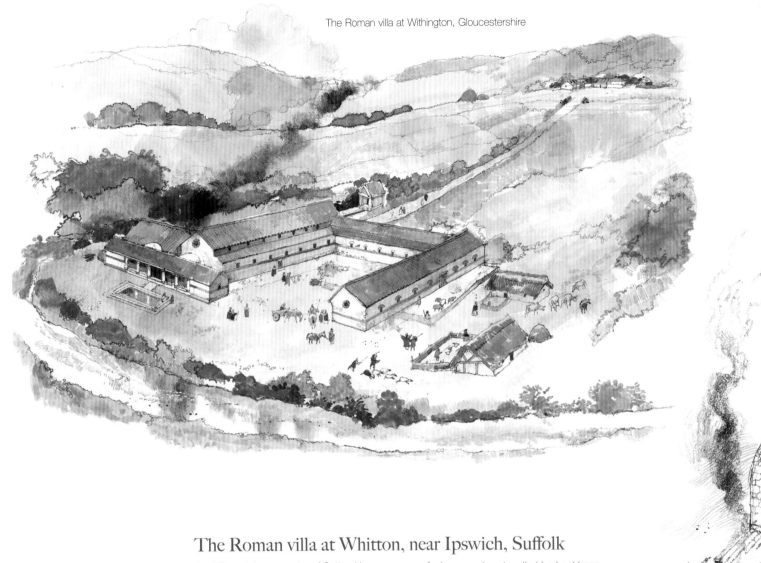

The Roman villa at Withington, Gloucestershire

The Roman villa at Whitton, near Ipswich, Suffolk

Basil Brown, the excavator of Sutton Hoo, excavated this site for four years but then abandoned it in 1950. Since then, unfortunately, a sprawling housing estate had been built over the villa. It was very cramped excavating the tiny back gardens and some disappeared entirely as the trenches were dug. Eventually we found some sections of mosaic floors and fragments of a hypocaust system that had not been removed by Brown and his men.

The villa must have been quite a large building as I have shown here although not as large perhaps as Brown's plans had suggested. The name of the site, 'Castle Hill', indicates that the presence of ruins had long been known here.

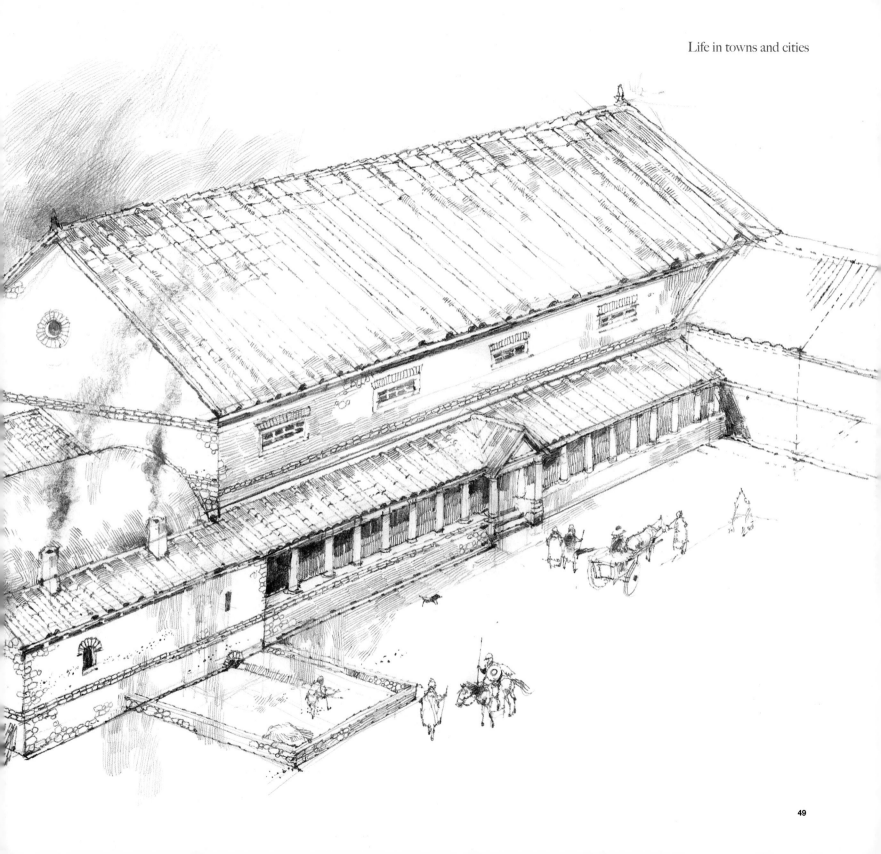

A reconstruction of a Roman hypocaust

The home comforts of the Roman hypocaust comprised of an extremely simple but highly-effective system. Logs were burnt in an outdoor kiln to generate hot air which circulated under the stone slabs held up by stacks of tiles which made up the floor of the building. Sometimes these slabs were covered over by mosaics.

We were able to demonstrate the effectiveness of the hypocaust with an experimental one we built in an apple orchard. It heated the floor up so well that it was too hot for us to stand on. No doubt rooms heated by hypocausts allowed the Romans to gather around and chat in comfort.

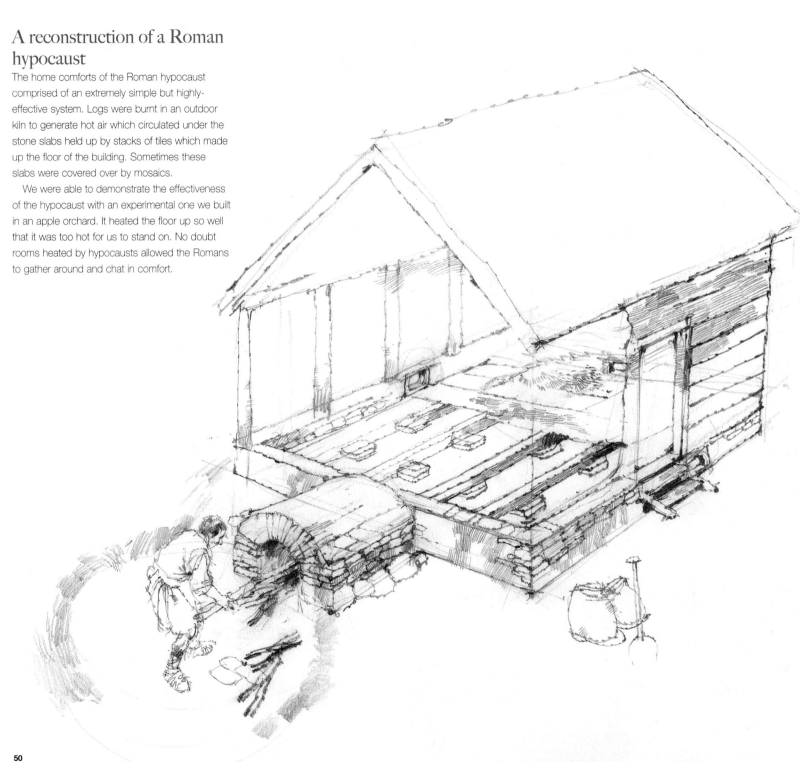

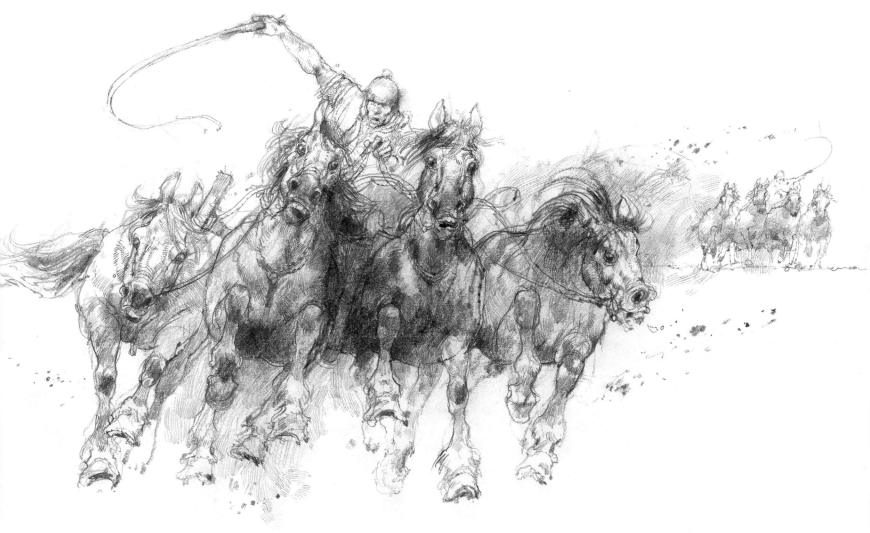

The Roman chariot race, Colchester, Essex

Recent excavations on the outskirts of Colchester exposed the only Roman chariot racecourse found in Britain. Like others elsewhere in the empire it measured about 70 x 350m and held thousands of people. Chariot racecourses and amphitheatres were hugely popular among Roman townsfolk and successive emperors and governors ensured their own popularity by providing such spectacles.

Each driver was pulled along in a chariot by a team of four ponies. Excitement built up as the chariots took part in a ceremonial procession before lining up at the starting point. Once they had been given the 'off' the race became a hazardous business as the lightly built chariots hurtled around a long central island. Man and animal alike were killed and injured as the ponies collided with each other and the chariots overturned at the bends, much to the delight of the crowd.

Having drawn the procession and buildings I concentrated on conveying the speed and danger of the race. I have illustrated a chariot coming around a bend towards us at full tilt with the driver trying to keep his balance. I love drawing horses anyway, and I could not resist the challenge of drawing four at the gallop.

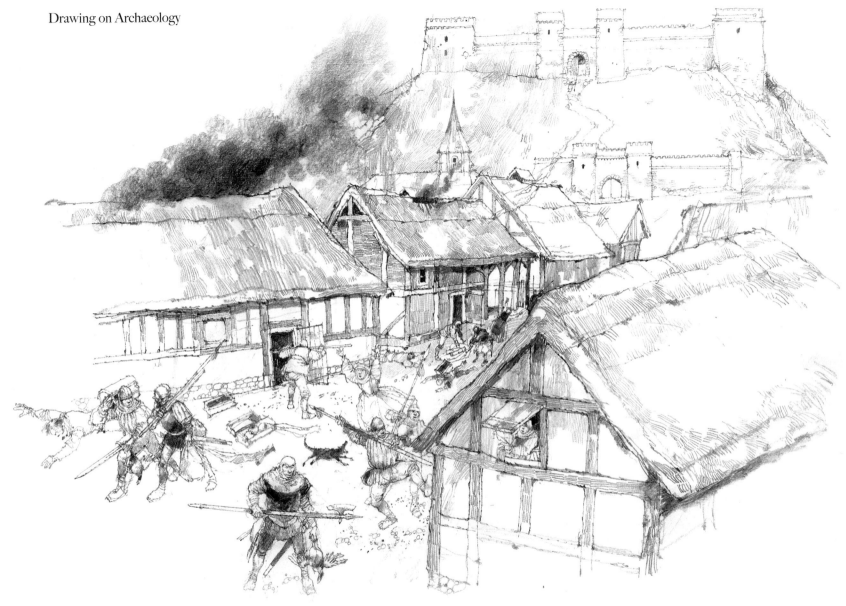

The sacking of Roxburgh, Scottish Borders

Roxburgh was located on a peninsula between the Rivers Tweed and Teviot and was accessible by river to the sea and by road to the Scottish lowlands. The town itself was guarded by a castle on the neck of the peninsula. Being so accessible yet easily defendable it became important during the twelfth century as a royal burgh.

This drawing shows the sacking of the town in 1296 by the English troops of Edward I. It was recaptured by the Scottish in 1313 when Sir James 'the Black' Douglas had his men approach the castle wearing cow skins on the night of an English feast day and then scale the walls using rope ladders mounted on long spears. After his death Roxburgh was retaken by the English in 1334.

The castle if not the town itself was held by the English until 1460 when James II of Scots died from an exploding cannon while besieging it and his son had it razed.

Roxburgh in peacetime, Scottish Borders

In between sackings Roxburgh continued to be an important town by trading with the continent and elsewhere through the seaport at Berwick-upon-Tweed, as this street scene with a market and several fine houses shows. With the capture of Berwick by the English in 1482, however, the town lost the use of the seaport and it went into a final decline. Eventually, all the citizens of Roxburgh died or left to live in nearby towns such as Kelso.

Nowadays there is nothing left of Roxburgh except the remains of the castle walls on the hill. Its name still lives on in the title of the Duke of Roxburgh, whose family still live a few miles away in the splendid stately home of 'Floors Castle'.

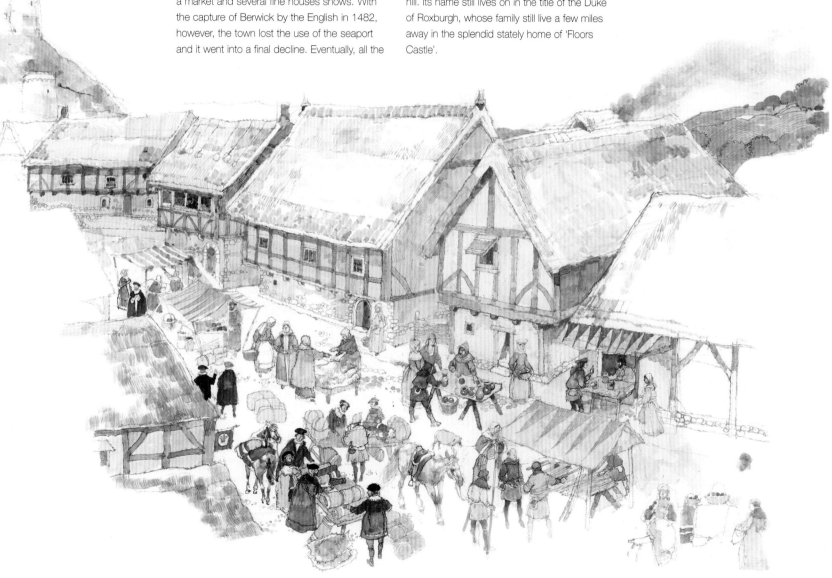

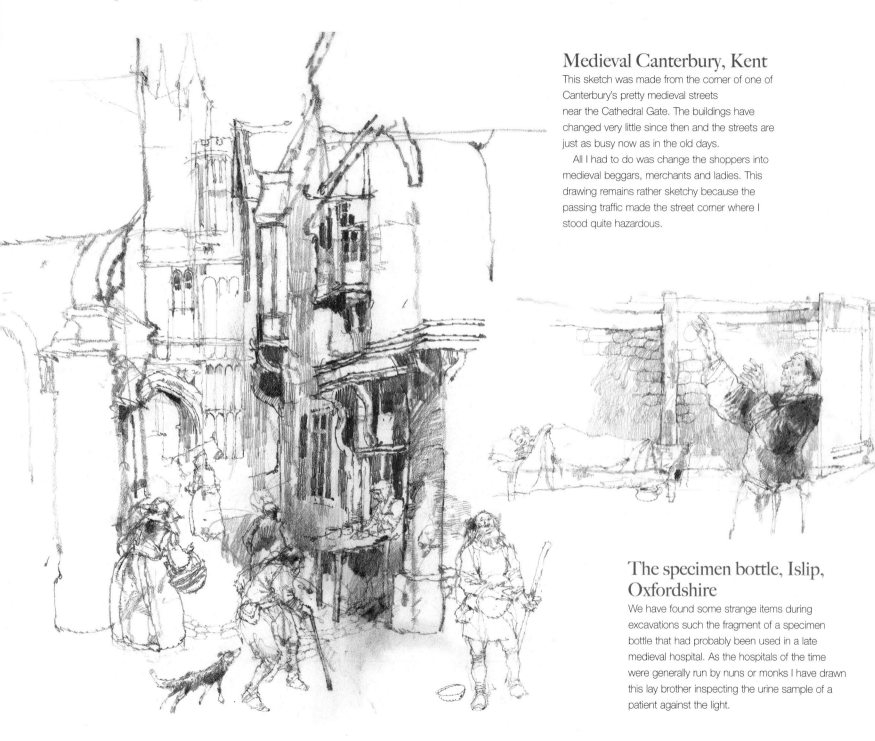

Medieval Canterbury, Kent

This sketch was made from the corner of one of Canterbury's pretty medieval streets near the Cathedral Gate. The buildings have changed very little since then and the streets are just as busy now as in the old days.

All I had to do was change the shoppers into medieval beggars, merchants and ladies. This drawing remains rather sketchy because the passing traffic made the street corner where I stood quite hazardous.

The specimen bottle, Islip, Oxfordshire

We have found some strange items during excavations such the fragment of a specimen bottle that had probably been used in a late medieval hospital. As the hospitals of the time were generally run by nuns or monks I have drawn this lay brother inspecting the urine sample of a patient against the light.

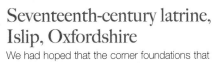

Seventeenth-century latrine, Islip, Oxfordshire

We had hoped that the corner foundations that we had found in the back garden of a house in Islip were those of a thirteenth-century chapel built in memory of Edward the Confessor in the town where he was recorded as having been born. It is likely that Henry III built the chapel as a demonstration to the general population of his solidarity with their last true Anglo-Saxon King.

Regrettably the foundations proved to have been nothing more than those of a seventeenth-century latrine, which I have reconstructed in use here.

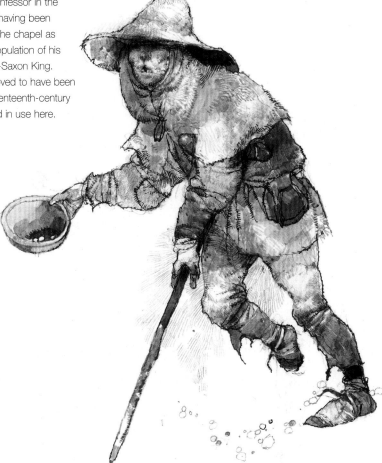

The lepers of Winchester, Hampshire

The leper hospitals were often strategically located near the main road leading into large towns and cities. Travellers would be approached by the evil smelling disfigured lepers begging for alms and often wearing a huge hat to cover their faces. I reconstructed this one from a skeleton we found on the site of a leper hospital just outside Winchester. I also made a clay bust of this victim.

Leprosy was a horribly 'democratic' disease. Whether you were rich or poor, if you caught leprosy you still ended up in the same hospital as all the other sufferers, begging for a living.

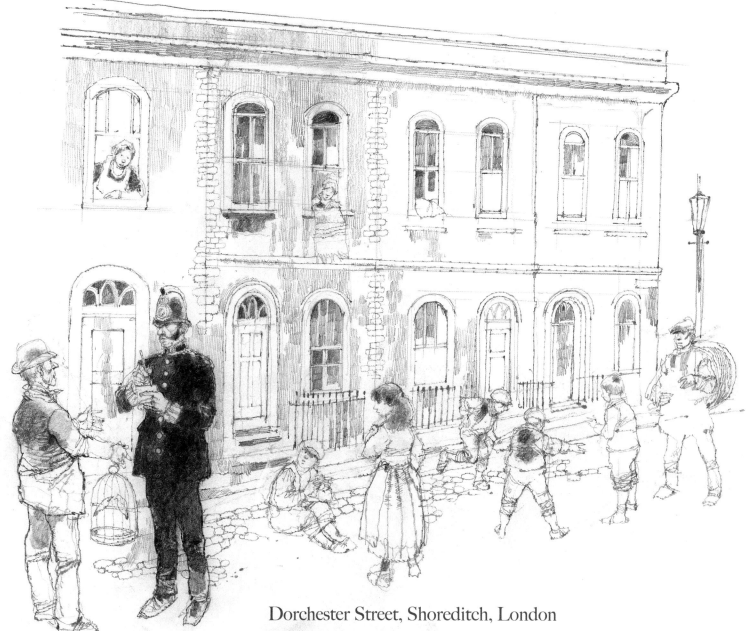

Dorchester Street, Shoreditch, London

Dorchester Street was largely destroyed by bomb damage during the Second World War but from the few surviving nineteenth-century houses I was able to reconstruct what it must have looked like.

The 'cat's meat man' would have done a roaring trade as cats were very important during the nineteenth-century to keep down rats and mice. Among the more shady local characters was a man who caught sparrows and dyed them yellow to sell them on as canaries. Eventually he had his collar felt by a constable.

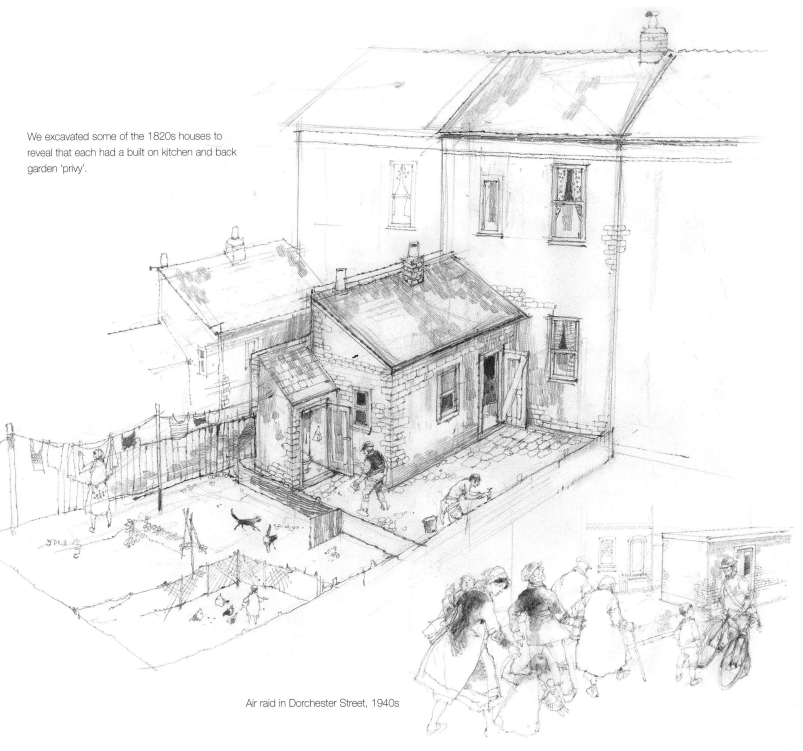

We excavated some of the 1820s houses to reveal that each had a built on kitchen and back garden 'privy'.

Air raid in Dorchester Street, 1940s

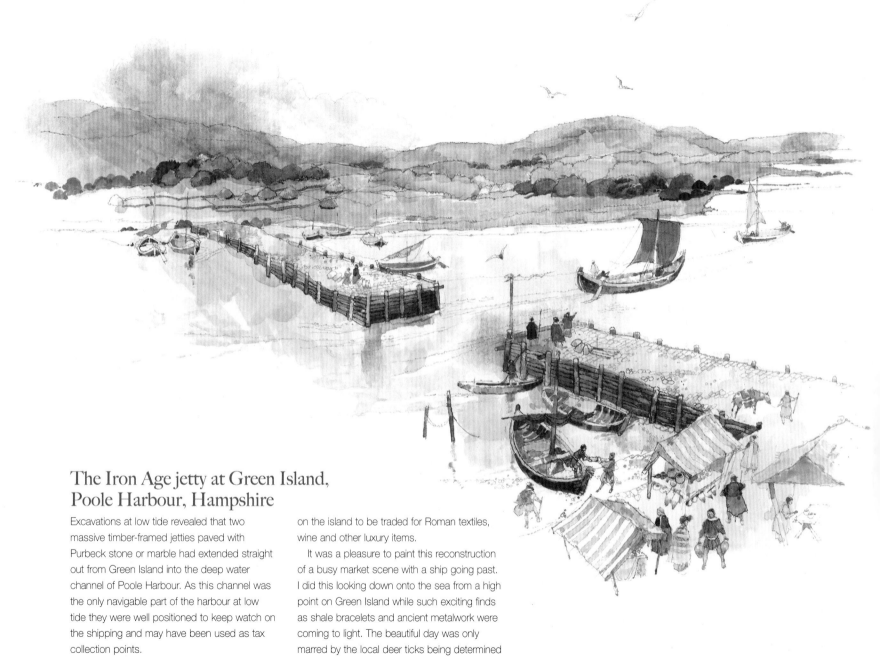

The Iron Age jetty at Green Island, Poole Harbour, Hampshire

Excavations at low tide revealed that two massive timber-framed jetties paved with Purbeck stone or marble had extended straight out from Green Island into the deep water channel of Poole Harbour. As this channel was the only navigable part of the harbour at low tide they were well positioned to keep watch on the shipping and may have been used as tax collection points.

We also knew from discarded shale cores and iron-slag heaps that shiny, black, oil-rich shale jewellery and ironwork were manufactured on the island to be traded for Roman textiles, wine and other luxury items.

It was a pleasure to paint this reconstruction of a busy market scene with a ship going past. I did this looking down onto the sea from a high point on Green Island while such exciting finds as shale bracelets and ancient metalwork were coming to light. The beautiful day was only marred by the local deer ticks being determined to have a share of the archaeologists. Before boarding the ferry back 'tick checks' were made and any intruders removed.

Trade, craft and industry

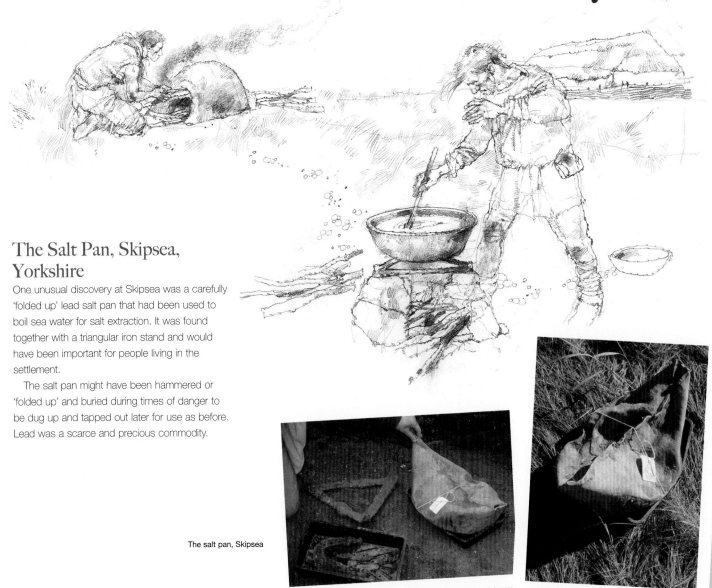

The Salt Pan, Skipsea, Yorkshire

One unusual discovery at Skipsea was a carefully 'folded up' lead salt pan that had been used to boil sea water for salt extraction. It was found together with a triangular iron stand and would have been important for people living in the settlement.

The salt pan might have been hammered or 'folded up' and buried during times of danger to be dug up and tapped out later for use as before. Lead was a scarce and precious commodity.

The salt pan, Skipsea

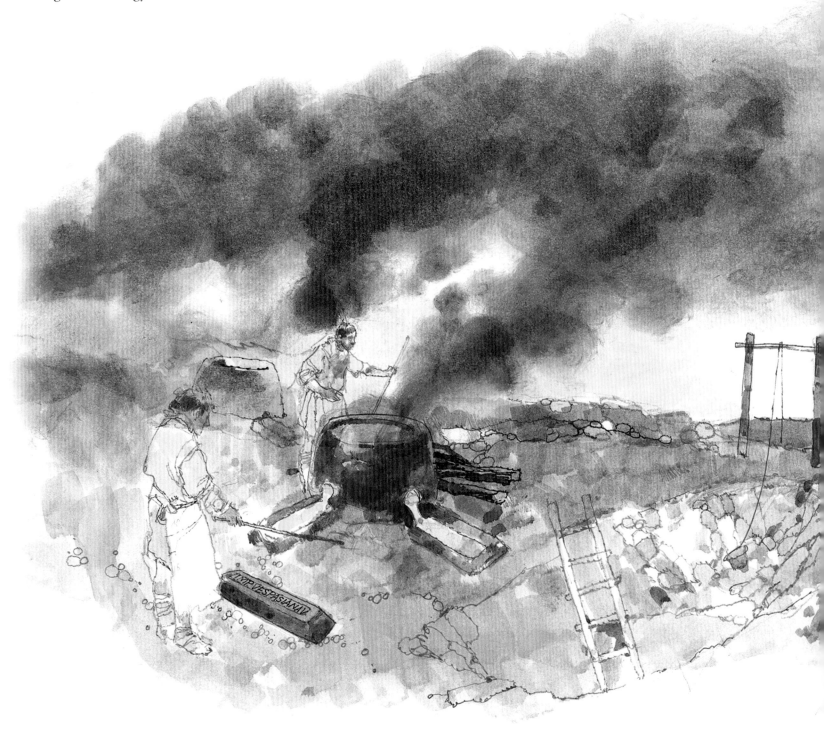

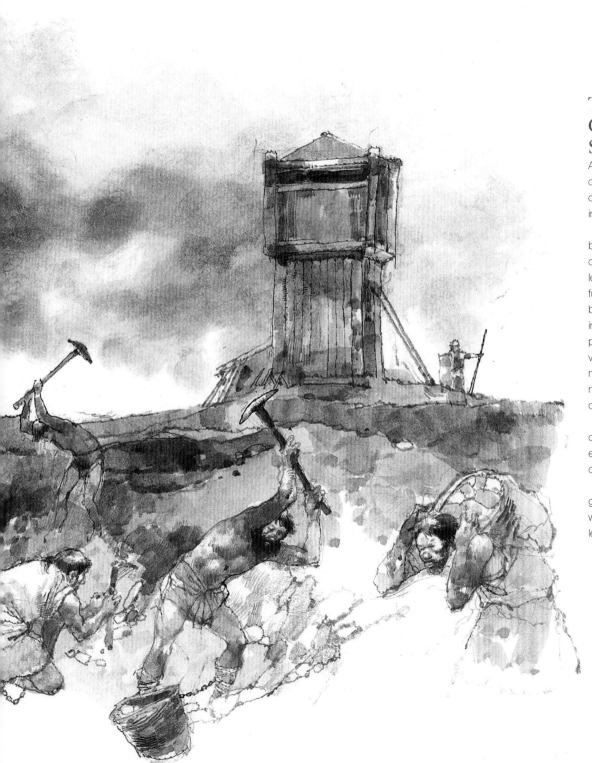

The Roman lead mines at Charterhouse, Mendip Hills, Somerset

Although now set in the rolling green countryside of the Mendip Hills the lead mines that were developed here by the Romans soon after they invaded in AD 43 must have been hell on earth.

During Roman times the area was pockmarked by small pits and galleries where gangs of slaves or convicts worked under the watchful eyes of legionaries stationed in watch towers. The air was full of the toxic fumes and black smoke given off by the smelting of lead ore and casting of lead ingots. The lead and arsenic from this would have poisoned the earth to render it almost devoid of vegetation. The lives of whoever worked these mines must have been short and miserable. Even now our excavations had to be stopped because of the high level of arsenic in the trenches.

Every ingot was stamped with name of the current Emperor and this site produced two excellent examples from the reign of Claudius, with one dateable to AD 48 or 49.

Drawing on a lovely sunny day in the green landscape it was hard to visualise the wretchedness that once abounded at the Roman lead mines at Charterhouse.

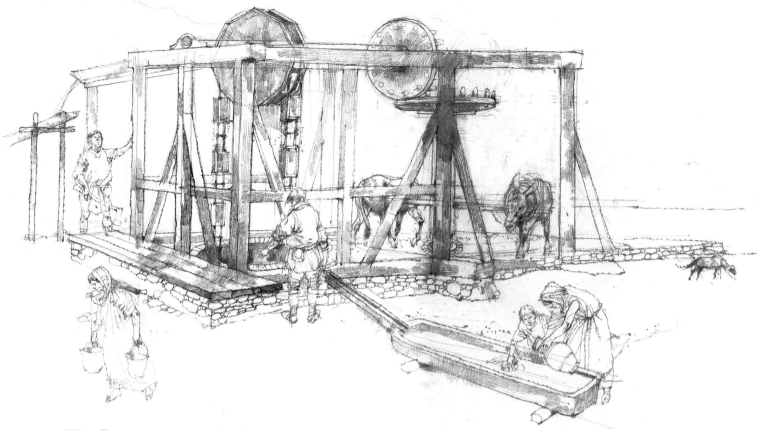

The Roman water wheel, City of London

I was privileged to be able to see and draw this expertly constructed water wheel based on the remains of an original one that had been recently found preserved in waterlogged ground at Gresham Street in the City of London, and tree-rings dated it to the restoration of the city after the Iceni revolt ended.

Weeks of hard work went into producing the full-size replica until the day I was there to see it assembled outside the workshop. After the pieces of wood were slotted together and the chain and buckets put in place the engineers and carpenters were overjoyed to see it miraculously work.

The water wheel can still be seen and even operated by four people to bring up water outside the Museum of London.

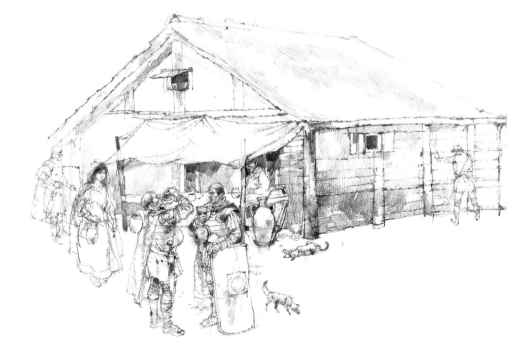

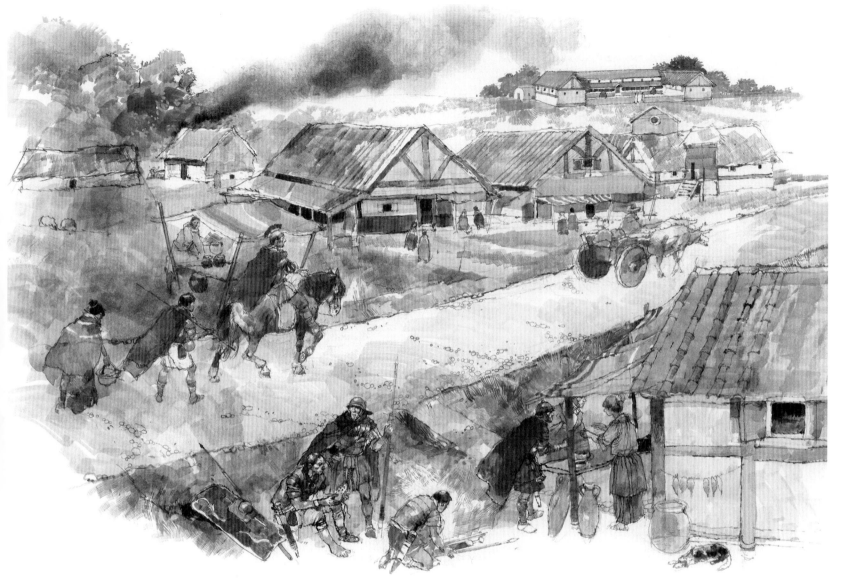

A Roman 'pub' at Cheshunt, Cheshire

While excavating near the major Roman road known as Watling Street at Cheshunt we came across the remains of a Roman alehouse. From the foundations and the neat and plain mosaic floor we gained a good idea of the size and layout of the half-timbered building.

I have recreated the ale house as it was then with servant girls serving drinks, legionaries relaxing, dogs dozing and wine jars scattered about. It must have been not unlike a modern country pub.

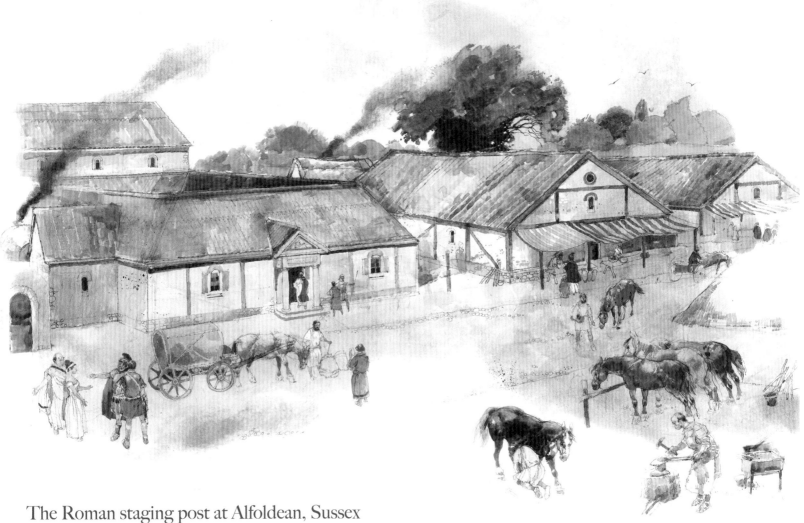

The Roman staging post at Alfoldean, Sussex

This Roman staging post at Alfoldean was situated where Stane Street, the road from Chichester to London, crossed the River Arun. The geophysics data suggested that there had been a conglomeration of buildings within a large rectangular defensive earthwork and others that were probably inns and shops along the road.

The walls surrounding the central courtyard of the central building suggested that this was a 'mansio'. The importance of the building was indicated by the presence of hypocaust tiles, tessellated floors and pieces of painted plasterwork. Nearby, limescaled tiles suggested a bathhouse. The mansio would also have had stables for horses and a blacksmith to re-shoe them.

The archaeologists concluded that since the mansio had been defended and yet had no sign of regular army occupation it had been a Roman customs post. Here tax officials would have mostly taxed the locally mined iron that was being taken up the road towards London. Any commodity was taxable to the Romans: donkeys, horses, carts, even concubines. These last must have led to many an argument with the officials.

The pottery found in the defensive ditches suggested that they were dug about AD 90 and in-filled during the third century AD, when mining for iron ore had declined.

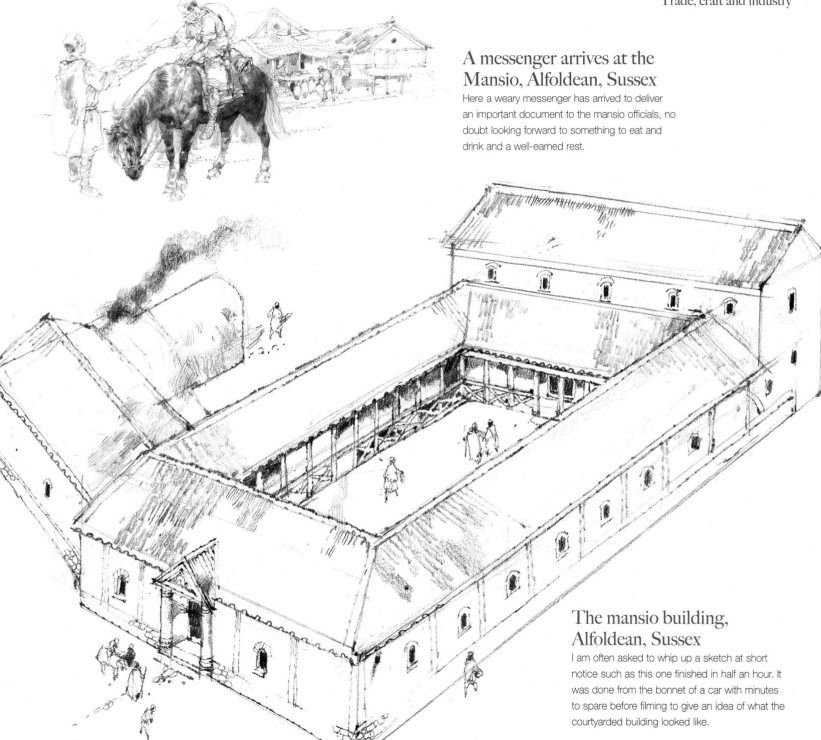

A messenger arrives at the Mansio, Alfoldean, Sussex

Here a weary messenger has arrived to deliver an important document to the mansio officials, no doubt looking forward to something to eat and drink and a well-earned rest.

The mansio building, Alfoldean, Sussex

I am often asked to whip up a sketch at short notice such as this one finished in half an hour. It was done from the bonnet of a car with minutes to spare before filming to give an idea of what the courtyarded building looked like.

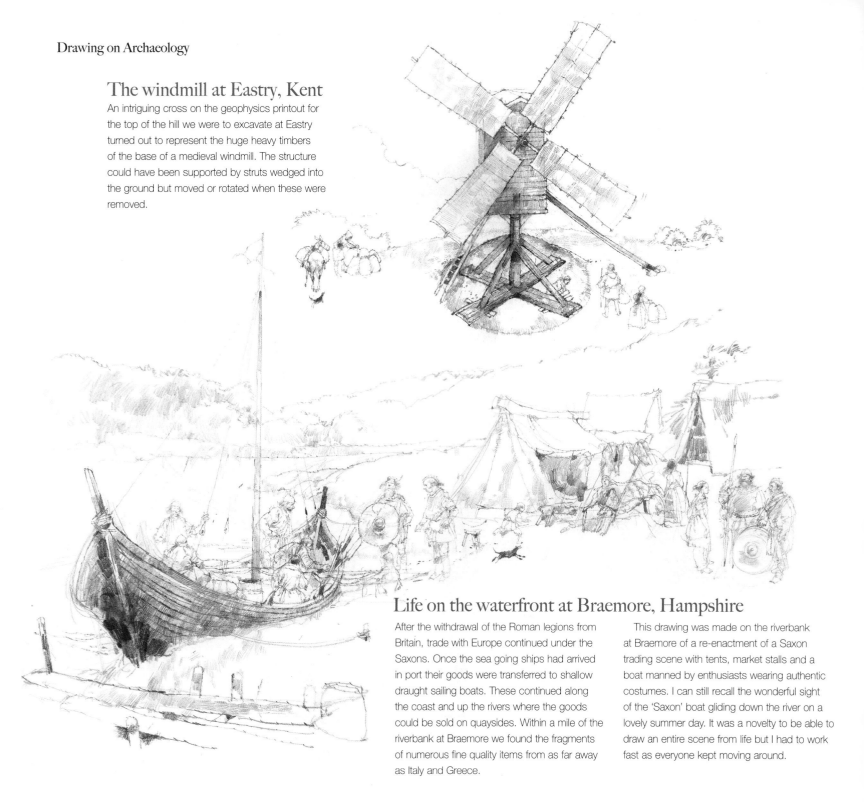

The windmill at Eastry, Kent

An intriguing cross on the geophysics printout for the top of the hill we were to excavate at Eastry turned out to represent the huge heavy timbers of the base of a medieval windmill. The structure could have been supported by struts wedged into the ground but moved or rotated when these were removed.

Life on the waterfront at Braemore, Hampshire

After the withdrawal of the Roman legions from Britain, trade with Europe continued under the Saxons. Once the sea going ships had arrived in port their goods were transferred to shallow draught sailing boats. These continued along the coast and up the rivers where the goods could be sold on quaysides. Within a mile of the riverbank at Braemore we found the fragments of numerous fine quality items from as far away as Italy and Greece.

This drawing was made on the riverbank at Braemore of a re-enactment of a Saxon trading scene with tents, market stalls and a boat manned by enthusiasts wearing authentic costumes. I can still recall the wonderful sight of the 'Saxon' boat gliding down the river on a lovely summer day. It was a novelty to be able to draw an entire scene from life but I had to work fast as everyone kept moving around.

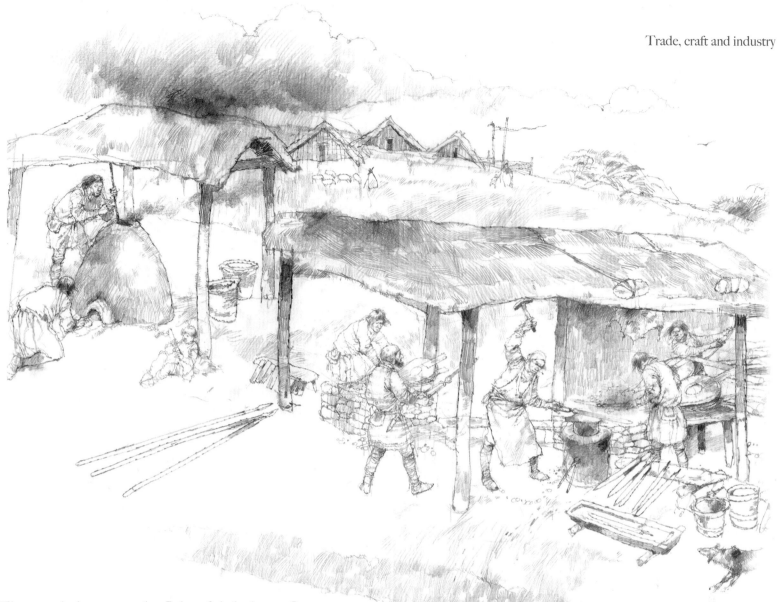

The workshops on the Isle of Athelney, Somerset

The Isle of Athelney was not strictly an island but a lone hill which in Saxon times was surrounded by marshes. King Alfred found it an ideal place to rearm and regroup and to launch raids from during his war against the Vikings.

We found evidence that Alfred had steepened the lower slopes of the island and also reused Iron Age defences with massive earthworks that would have been surmounted by timber palisades. Behind these defences we found signs that he had set up a series of kilns and workshops where iron was produced and spearheads and swords hammered out and finished by blacksmiths and craftsmen.

When the final battle came it was ferocious and the *Anglo-Saxon chronicles* record that Alfred's army did not spare any of the enemy except the Viking leader Guthrum and a handful of his followers. Alfred had him converted to Christianity and baptized but his good behaviour did not last long.

Later Alfred built and abbey on Athelney as a thanks giving gesture for his being able to drive the Danes first out of Wessex and then by 886 the south of England.

The medieval blast furnace near Oakamoor, Staffordshire

I made this reconstruction of a busy medieval blast furnace in an unspoilt Staffordshire valley with a small stream running by. It was a beautiful summer day and a joy to be painting outside.

We were looking for a blast furnace so well documented that we even knew the names of some of the people who worked at it. We found plenty of furnace clinker or 'slag' within the trenches we dug around a Victorian cottage and also evidence of a small bridge across the stream.

After three days of excavation the archaeologists concluded that the blast furnace had probably been on the site of Furnace Cottage itself. Short of demolishing the building the archaeology had to remain undisturbed and the reconstruction left to my imagination.

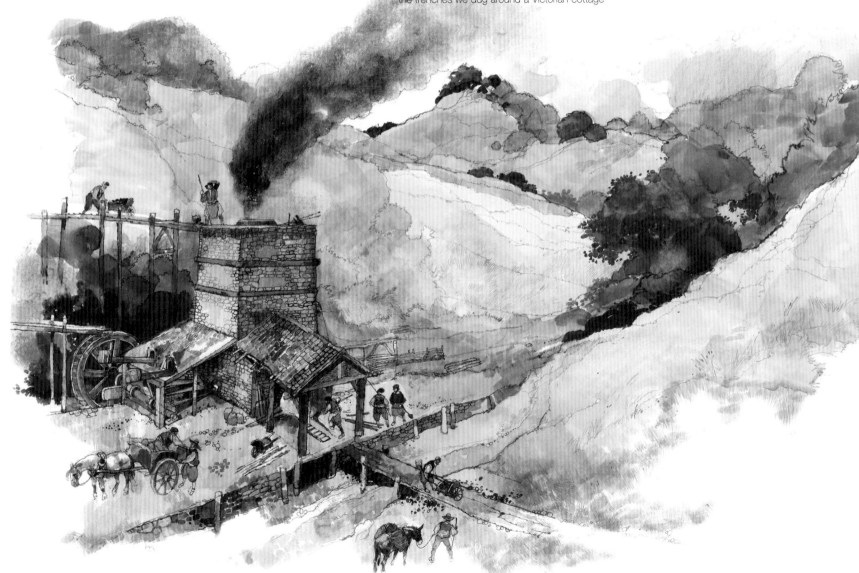

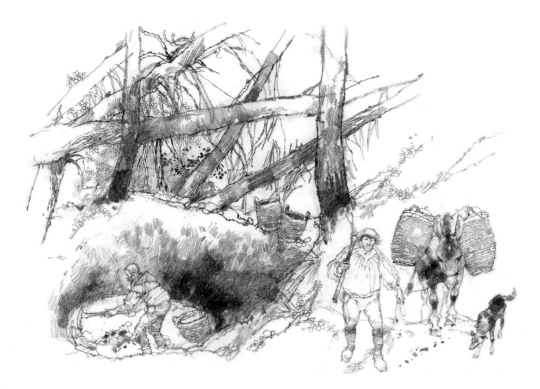

The bloomery furnace at East Wall Farm near Oakamoor, Staffordshire

Down in the valley a well-preserved bloomery furnace was excavated along with pottery which suggested that it had been in use between the twelfth and fourteenth centuries. The air flow for this furnace might have been provided by either a water-wheel powered by the stream or by bellows powered manually as shown in my drawing.

A coal and iron ore pit at East Wall Farm near Oakamoor, Staffordshire

On the National Trust property of East Wall Farm, 1 mile or so away, we had better luck. It seemed that a fast-flowing stream on the valley floor could have powered a water-wheel while several small disused pits in the overlooking woodland might have been mines for the coal needed as fuel and the iron ore used to make the iron objects themselves.

I was asked to investigate the pits in the woodland. I found one particularly deep hollow with a mixture of both coal and iron ore seams, the iron turning the rainwater rust red. The sides were steep so it must have been very hard work to extract these raw materials. From here donkeys would have carried them over the ridge and down into the valley below.

To get a good view of the hollow for this reconstruction I had to wedge myself between two trees.

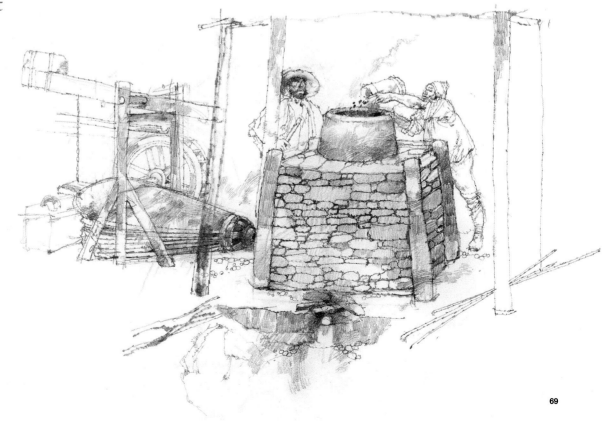

Tudor brick production, Esher Palace, Surrey

Bricks were initially imported from Holland and rapidly became popular building materials in Tudor England. Most of the Tudor royal palaces were built of slim bricks that proved their versatility in the construction of intricate stairways, vaulted roofs and decorative features.

This drawing of a brick production line was done on the spot at a brick kiln with modern workers being substituted by Tudor ones. Wonderful handmade bricks were produced almost identical to the Tudor ones we excavated on the site of the palace.

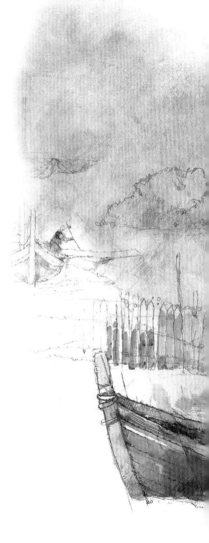

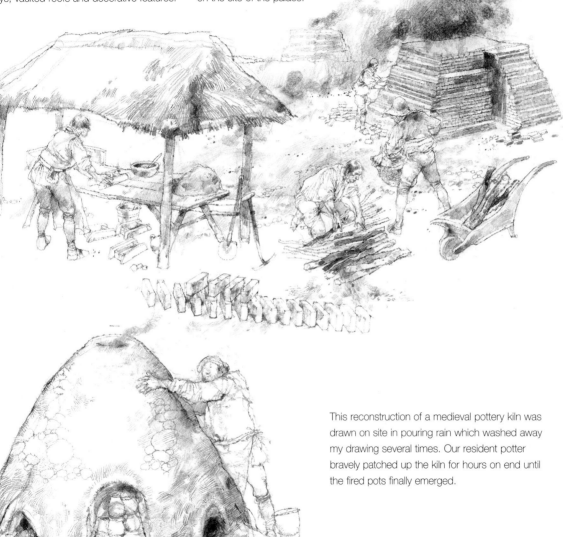

This reconstruction of a medieval pottery kiln was drawn on site in pouring rain which washed away my drawing several times. Our resident potter bravely patched up the kiln for hours on end until the fired pots finally emerged.

The wharf at St Osyth, Essex

The series of timber palisades found running parallel to the riverbank were dated to the sixteenth century and formed a wharf where boats were pulled up for the unloading and loading of such items as timber, pottery and farm produce. A cart road was also discovered leading away from the river to the settlement on higher ground.

During the mid-1600s a great storm was recorded as having struck this area and probably swept most of the timber posts into the river.

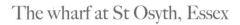

Angel Street, Manchester

Angel Street was made up of a row of Georgian houses in the shadow of the local church. By the middle of the nineteenth century the street had become run down and life went on as much outdoors as indoors as there was more room in the street!

 Today after redevelopment into modern blocks of flats there is nothing left of the original street except for a lovely old signpost saying 'Angel Street'.

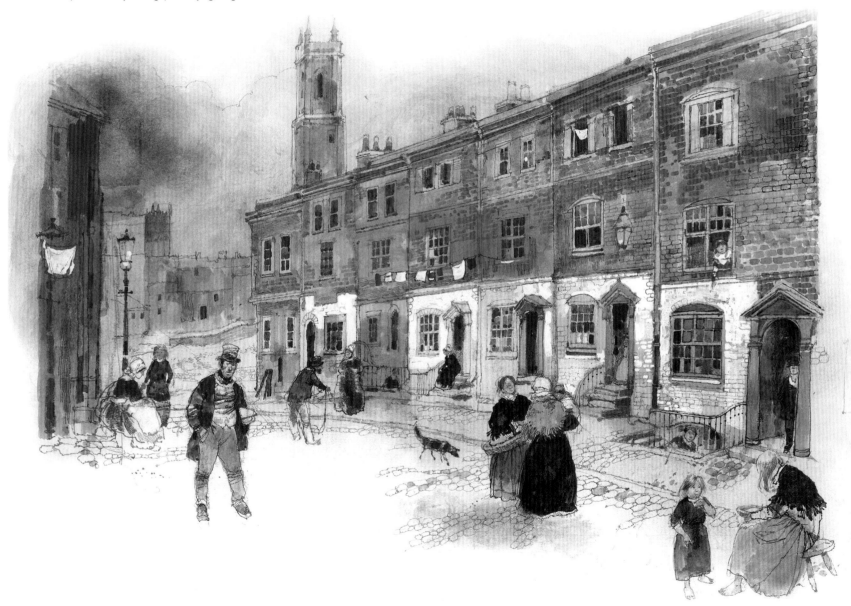

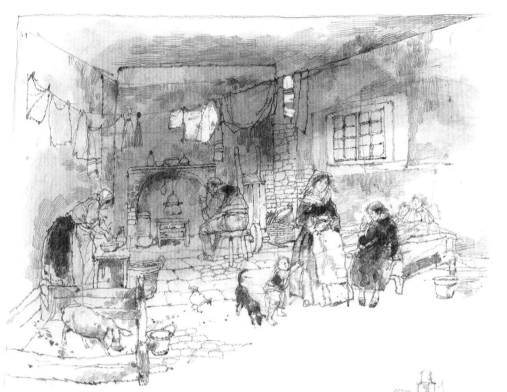

Cellar dwelling in Angel Street, Manchester

The Industrial Revolution saw a huge influx of poor people from the countryside into the cities causing their populations to grow at an unprecedented rate. This in turn gave rise to a grave shortage in accommodation with every available room being taken up, including the cellars of the houses. It was not unusual for as many as a dozen people to live in one cellar along with their domestic animals such as pigs. There is even a record of a large family sharing their cellar with a donkey.

We excavated one such cellar at Angel Street in Manchester and found such moving nineteenth-century personal items as clay pipes and a tiny child's shoe. It was hard to imagine how a large group of people could live in such a tiny airless place.

Cotton Mills, Manchester

The cotton mills employed mostly women and children who worked in dusty, unhealthy conditions. The women worked mostly on the looms while the children scrabbled about under them to pick up loose fluffs of cotton.

The fine dust got into their lungs and the noise affected their hearing but the cotton industry provided a living for many generations of Midlands women.

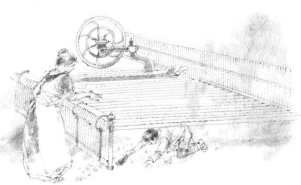

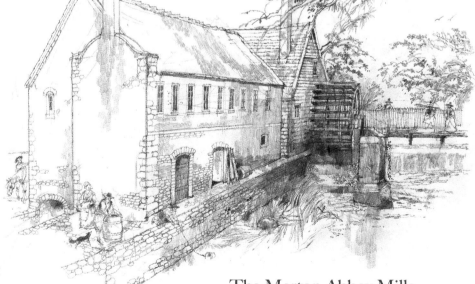

The Merton Abbey Mills

London in the eighteenth century: a site of watermills going back centuries. The great wheel is still in place and working.

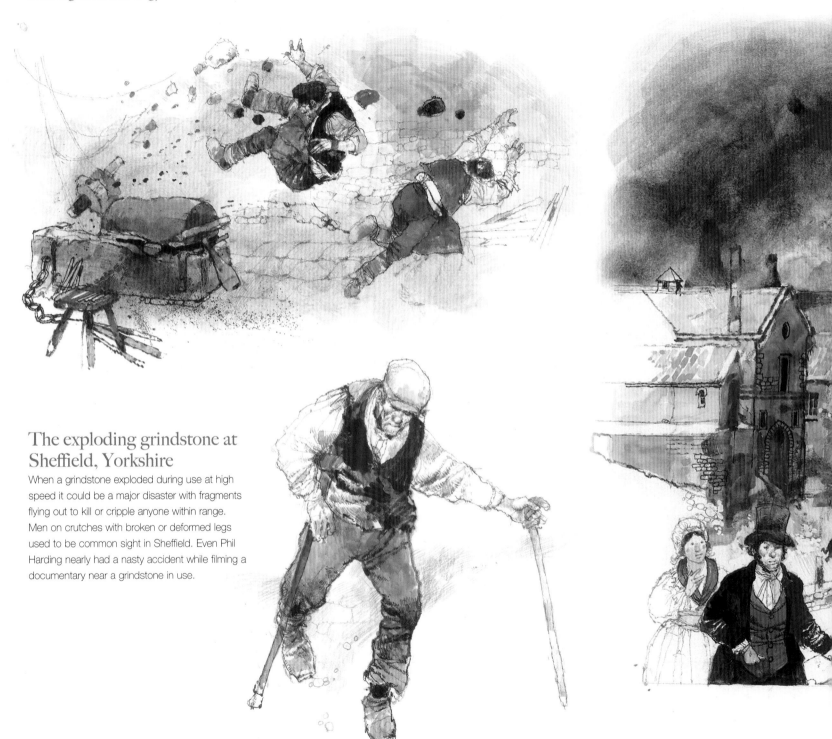

The exploding grindstone at Sheffield, Yorkshire

When a grindstone exploded during use at high speed it could be a major disaster with fragments flying out to kill or cripple anyone within range. Men on crutches with broken or deformed legs used to be common sight in Sheffield. Even Phil Harding nearly had a nasty accident while filming a documentary near a grindstone in use.

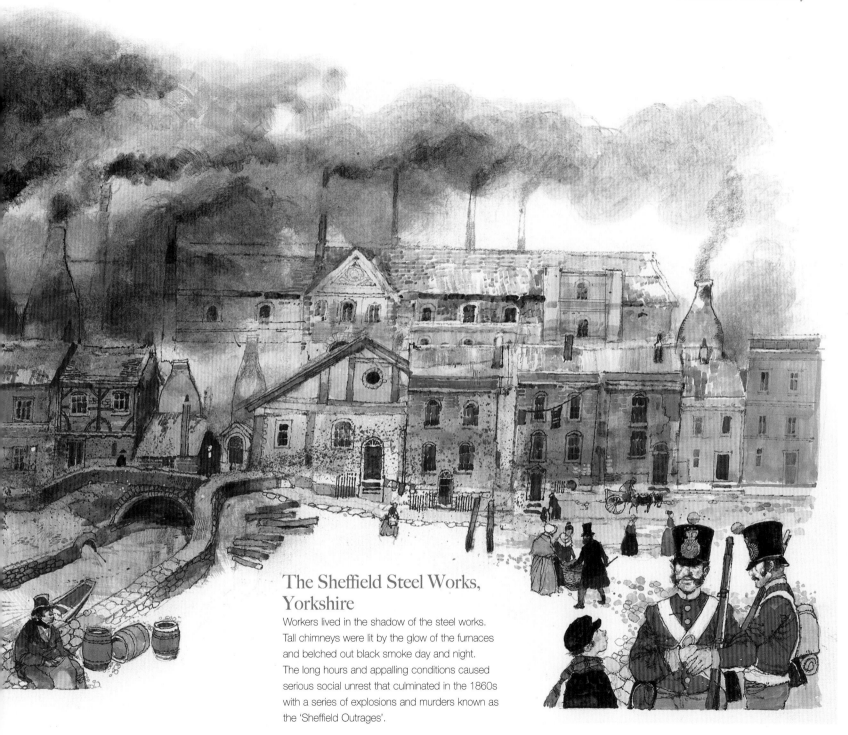

The Sheffield Steel Works, Yorkshire

Workers lived in the shadow of the steel works.
Tall chimneys were lit by the glow of the furnaces
and belched out black smoke day and night.
The long hours and appalling conditions caused
serious social unrest that culminated in the 1860s
with a series of explosions and murders known as
the 'Sheffield Outrages'.

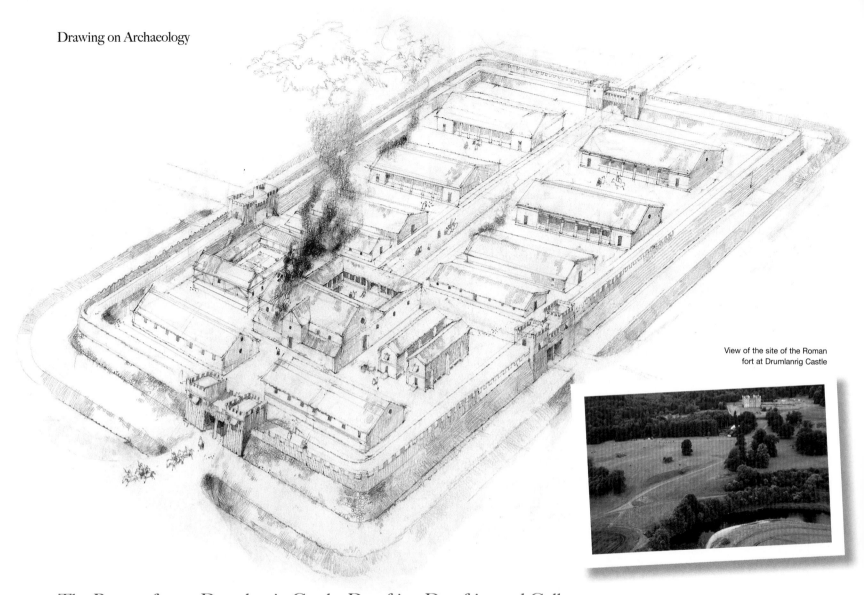

View of the site of the Roman fort at Drumlanrig Castle

The Roman fort at Drumlanrig Castle, Dumfries, Dumfries and Galloway

The Roman fort at Drumlanrig was first noticed from parch marks during the particularly hot summer of 1984. It is situated a few hundred yards from Drumlanrig Castle and overlooks a crossing point of the River Nith.

The second century AD fort appears to have had the typical rectangular 'playing card' layout with a surrounding bank, palisade and ditch and four gateways. At the centre was the administrative centre

('principia') and commanding officer's house ('praetorium'). Around the buildings were the soldiers' living quarters, granary and perhaps cavalry stables.

Drumlanrig was probably occupied by auxiliary cavalry troops. These specialist troops retained the helmets, plate and chain mail of their native land rather then the regulation armour of legionaries. The Romans were usually careful not to deploy troops local to the area

because their loyalty could not be relied upon in times of civil unrest.

There were signs that when the Romans abandoned the fort they burnt it down and they may have filled in the ditches. This prevented the fort from being taken over by the local Pictish tribes. With smoke rising behind them the troops were to cross the River Nith one last time before heading south.

Life in forts and castles

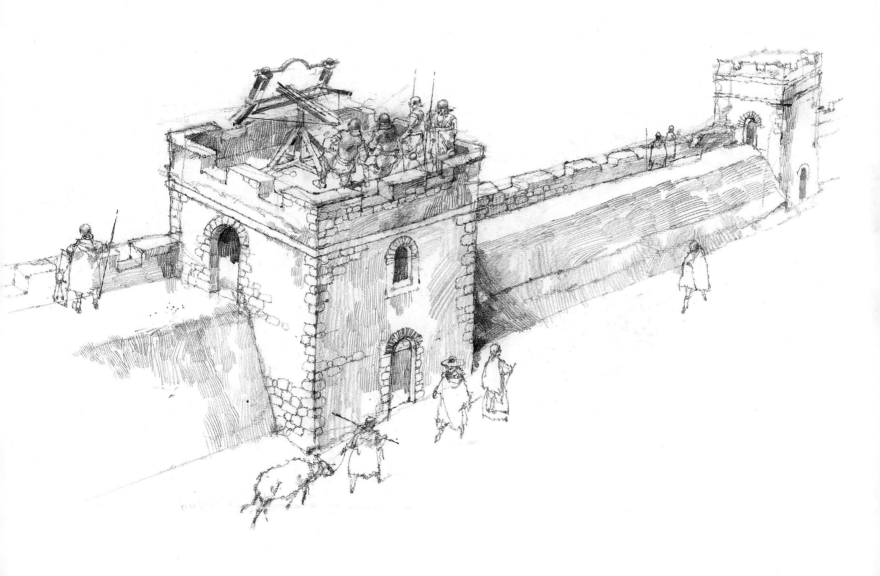

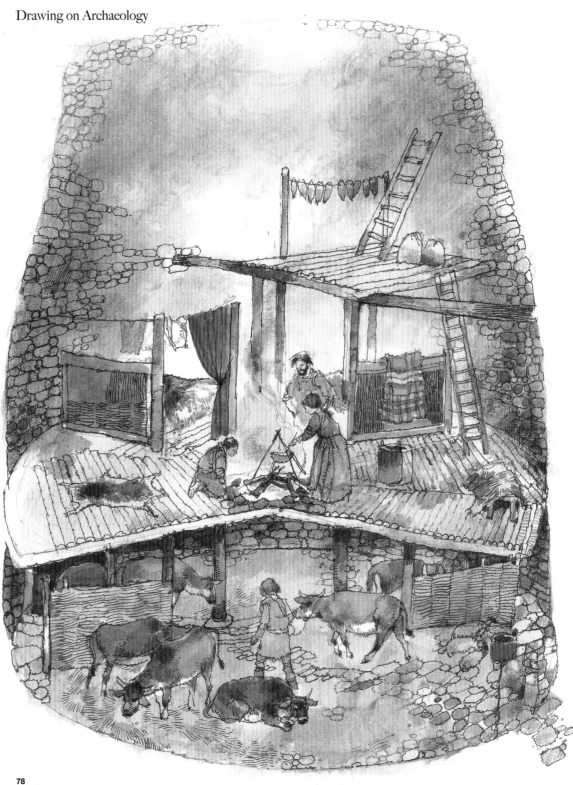

The broch at Applecross, Wester Ross

Brochs are stone towers that were mostly built on the east coast of Scotland during the first millennium BC but continued to be used into early medieval times.

The one we excavated on the west coast at Applecross, or A'Chomraich in Gaelic, overlooked the Island of Skye. Our excavation of the stone foundations showed it to have been a typical broch with two thick, concentric, drystone walls that supported a circular staircase which led to different floor levels. The finding of a single black glass bead and pottery suggested it to be of an Iron Age date.

Animals would have been kept on the ground floor while the storage and living quarters were on the upper levels. The roof was probably thatched to allow the smoke to escape through it. It has been suggested, however, that the hot air from the fire might cool and sink between the concentric walls to circulate warm air throughout the building. Certainly double walls would have kept it dry inside.

As my reconstruction shows the broch must have been an intimidating symbol of defiance looming out of the mist over passing boats.

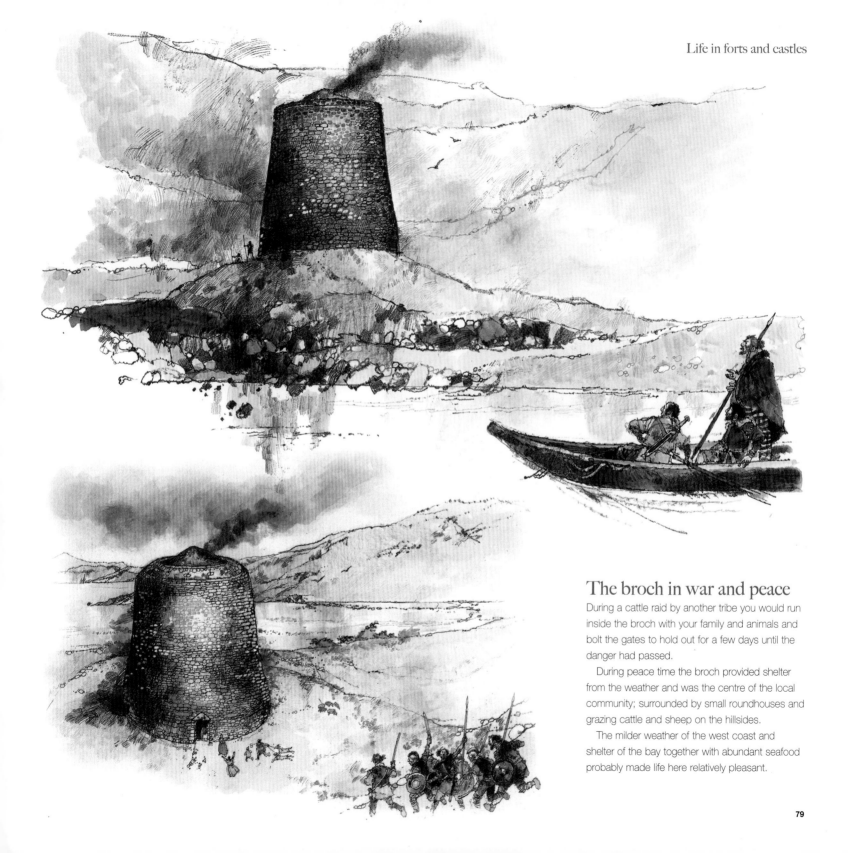

The broch in war and peace

During a cattle raid by another tribe you would run inside the broch with your family and animals and bolt the gates to hold out for a few days until the danger had passed.

During peace time the broch provided shelter from the weather and was the centre of the local community; surrounded by small roundhouses and grazing cattle and sheep on the hillsides.

The milder weather of the west coast and shelter of the bay together with abundant seafood probably made life here relatively pleasant.

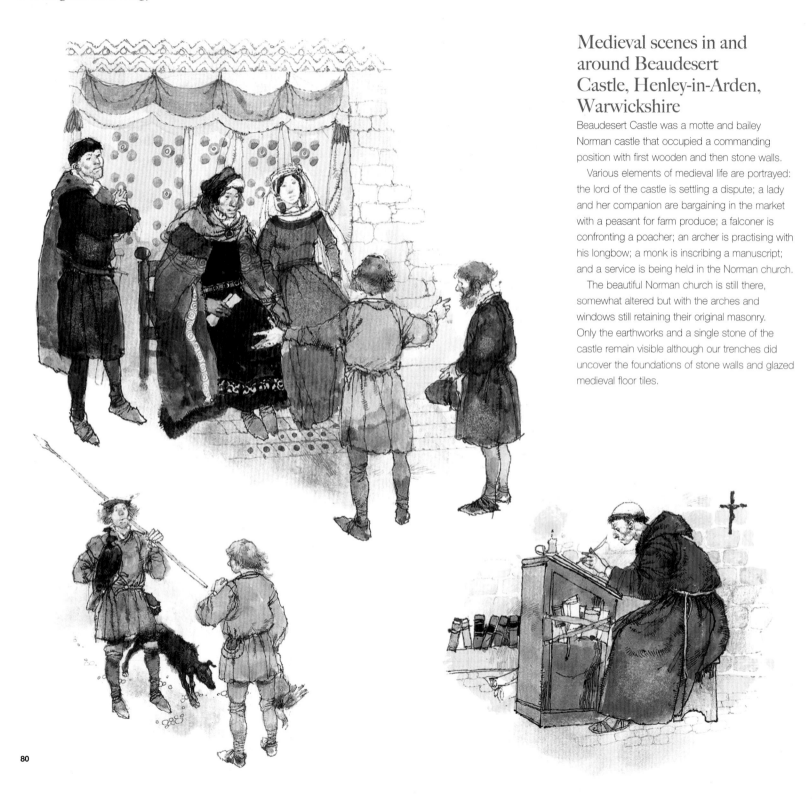

Medieval scenes in and around Beaudesert Castle, Henley-in-Arden, Warwickshire

Beaudesert Castle was a motte and bailey Norman castle that occupied a commanding position with first wooden and then stone walls.

Various elements of medieval life are portrayed: the lord of the castle is settling a dispute; a lady and her companion are bargaining in the market with a peasant for farm produce; a falconer is confronting a poacher; an archer is practising with his longbow; a monk is inscribing a manuscript; and a service is being held in the Norman church.

The beautiful Norman church is still there, somewhat altered but with the arches and windows still retaining their original masonry. Only the earthworks and a single stone of the castle remain visible although our trenches did uncover the foundations of stone walls and glazed medieval floor tiles.

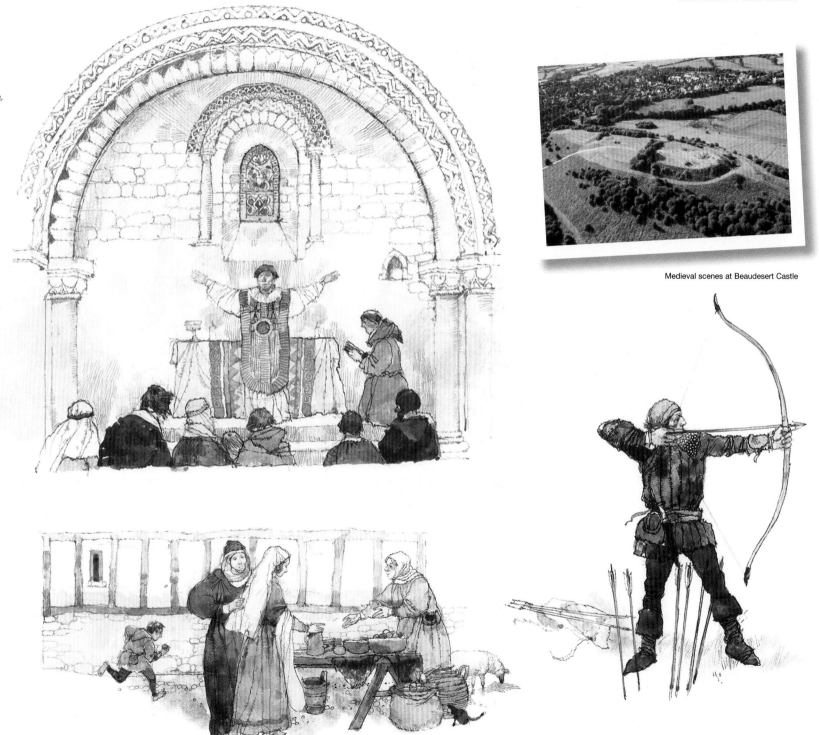

Medieval scenes at Beaudesert Castle

Queenborough Castle, Isle of Sheppey, Kent

Edward III had Queenborough Castle built in French style from about 1361 to please his French Queen Philippa of Hainault, as well as having the town named after her. From the Island of Sheppey it protected the entrance of the River Medway and the navigable channel that led to the Thames known as the Swale. A seventeenth-century engraving suggests that it looked like a typical French castle with six very tall circular towers overlooking the circular stone wall. It was demolished by Cromwell during the seventeenth century and all that remains of it today is the castle well on Queenborough Green.

The castle was never taken and was only besieged once in 1450 by the rebel army of Jack Cade. The handful of defenders made so much noise in different parts of the castle fort that Cade was convinced that he faced a large well-armed garrison and moved on towards London. We found several beautifully carved stone cannon balls which were probably intended to be fired from three mortars or 'bombards' sent up from the Tower of London.

I drew this reconstruction on the basis of the seventeenth-century engraving and a few surviving maps and layouts.

(Right) The Castle site, Isle of Sheppy, and (far right) a trench that produced stone cannon balls

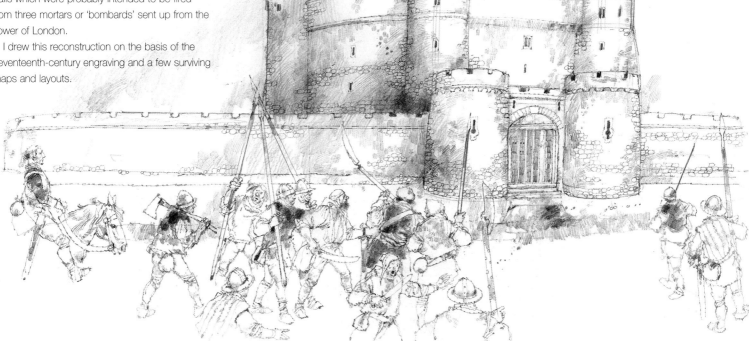

John Taylor arrives at Queenborough, Isle of Sheppey, Kent

One of the curious stories of Queenborough relates to the seventeenth-century eccentric John Taylor, a poet and self-promoter who experimented with various crazy ideas.

He and a companion constructed a makeshift boat made of layers of paper with two oars made of large pieces of dried cod fish. In 1619 they somehow managed to row all the way down the River Thames to Queenborough without sinking to receive a hero's welcome from the mayor and other prominent citizens. Taylor had intended to donate his boat to the town as a commemorative trophy, but by the time the meal in his honour was over the locals had torn the boat to pieces for souvenirs.

In 2005 two young people tried to repeat the trick and it worked perfectly.

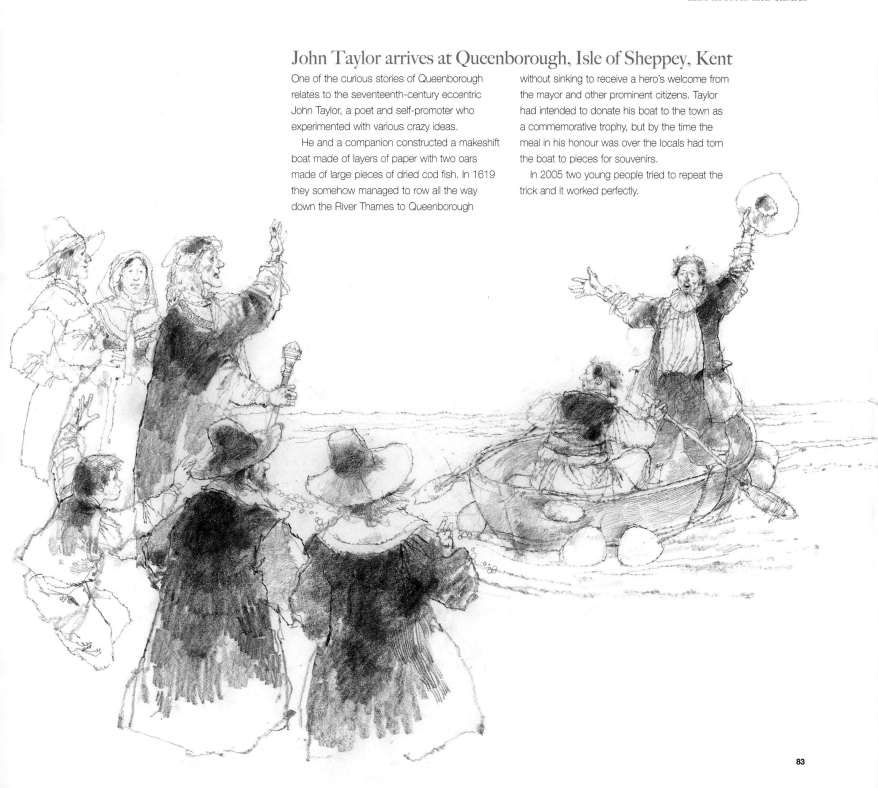

Drumlanrig

Drumlanrig was probably occupied by auxiliary
cavalry troops. These specialist troops retained the
helmets, plate and chain mail of their native land
rather than the regulation armour of legionaires.

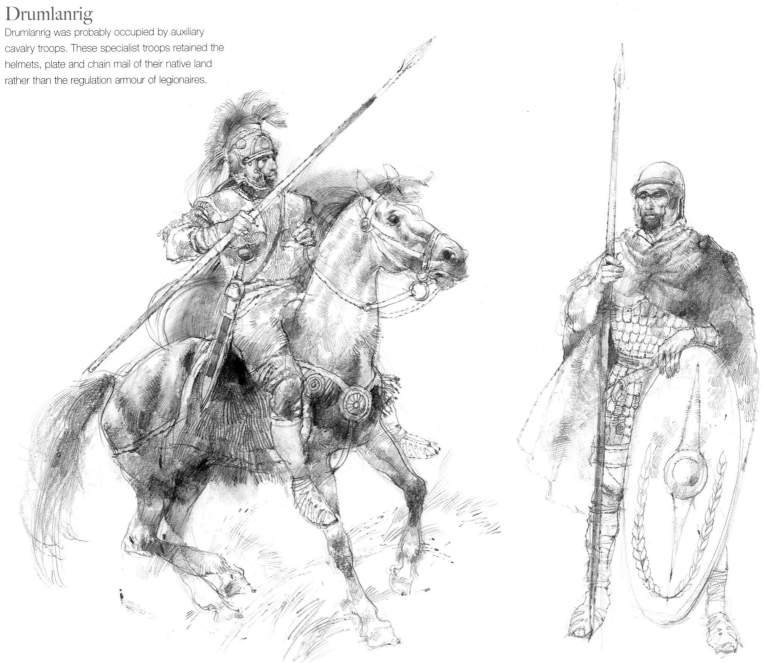

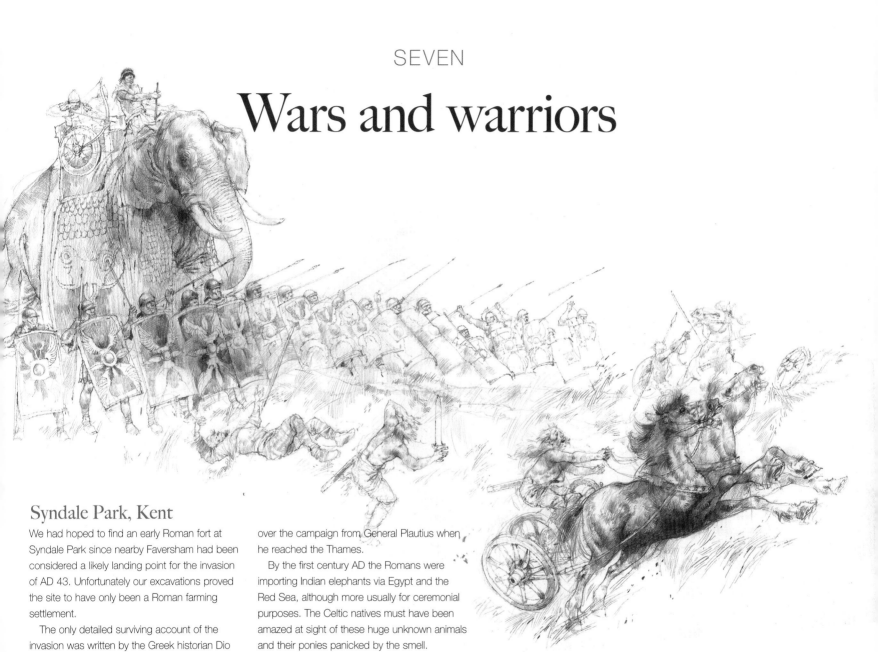

Wars and warriors

Syndale Park, Kent

We had hoped to find an early Roman fort at Syndale Park since nearby Faversham had been considered a likely landing point for the invasion of AD 43. Unfortunately our excavations proved the site to have only been a Roman farming settlement.

The only detailed surviving account of the invasion was written by the Greek historian Dio Cassius about 150 years after it took place. He mentions that elephants and other equipment were assembled on what is now the French coast, in readiness for Emperor Claudius to take over the campaign from General Plautius when he reached the Thames.

By the first century AD the Romans were importing Indian elephants via Egypt and the Red Sea, although more usually for ceremonial purposes. The Celtic natives must have been amazed at sight of these huge unknown animals and their ponies panicked by the smell.

This drawing contrasts the disciplined ranks of the legions accompanied by the elephants with the skirmishing Celts drawn along on chariots by their bolting ponies.

The Iceni uprising, Colchester, Kent

After the Roman invasion of Britain in AD 43 the Iceni of East Anglia lived in a kind of 'armed truce' with the Romans. The Iceni king made Emperor Nero joint benefactor in his will in the hope that this might ingratiate his family and people to him. When he died in AD 60 or AD 61, however, the Romans took over all Iceni possessions and his queen Boudicca was publicly humiliated and her two daughters were raped. Boudicca then incited the Iceni and other dissenting tribes to attack the Roman towns in the south of Britain.

Colchester fell first with the retired legionaries who lived there. My illustration of the massacre may be disturbing but the reality must have been far worse as no one was left alive and the city was burnt to the ground. The Roman governor Suetonius realised that it would be futile to try to defend London and St Albans and they fell soon after. The Roman historian Tacitus thought that in all, 70,000 Roman citizens and their retainers had perished.

Some months after the rebellion had started Suetonius had rallied enough of the Fourteenth and Twentieth Legions to confront the Celtic horde who were several times their number.

Tacitus states that after withstanding the charges of the Celtic warriors the legionaries formed a wedge to pin them against the wagons their families were watching from. A similar number of people may have died during this battle as during the rebellion itself. Boudicca herself committed suicide rather than facing the possibility of capture.

During our excavation of Roman sites we often came across signs of burning and destruction which must have dated from those stormy times.

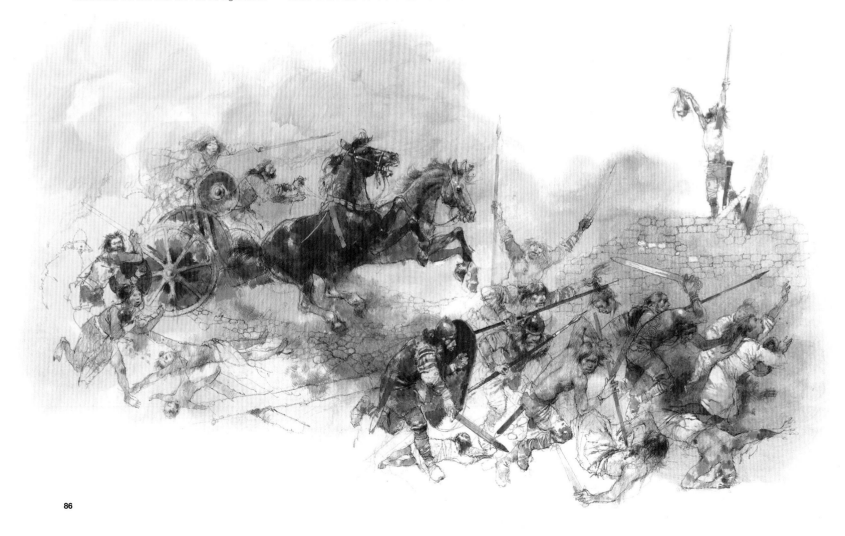

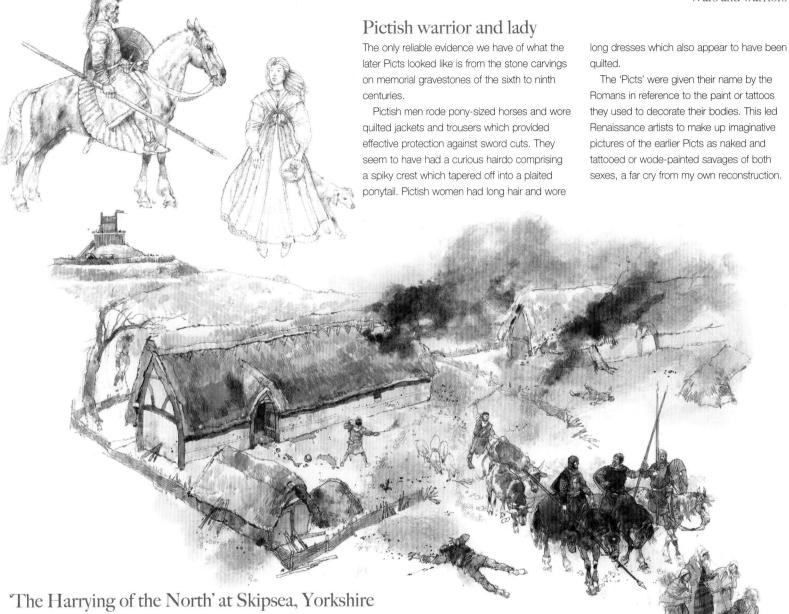

Pictish warrior and lady

The only reliable evidence we have of what the later Picts looked like is from the stone carvings on memorial gravestones of the sixth to ninth centuries.

Pictish men rode pony-sized horses and wore quilted jackets and trousers which provided effective protection against sword cuts. They seem to have had a curious hairdo comprising a spiky crest which tapered off into a plaited ponytail. Pictish women had long hair and wore long dresses which also appear to have been quilted.

The 'Picts' were given their name by the Romans in reference to the paint or tattoos they used to decorate their bodies. This led Renaissance artists to make up imaginative pictures of the earlier Picts as naked and tattooed or wode-painted savages of both sexes, a far cry from my own reconstruction.

'The Harrying of the North' at Skipsea, Yorkshire

William the Conqueror soon subdued the south of England after the Battle of Hastings in 1066 but for some time after the north continued to give him trouble.

William finally lost his patience with the North Country in 1069 and sent his knights to bring it to heel once and for all. Most of the region was laid to waste during 'The Harrying of the North' with villages razed, farms destroyed, men hung or put to the sword and women and children left to starve.

The site we excavated near Skipsea suggests that some of the inhabitants in the area did survive this Norman 'cleansing' to begin a new settlement after the destruction of others nearby under the domination of Skipsea Castle.

Pottery finds suggest that the settlement declined during medieval times as the present town of Skipsea grew until it was finally abandoned and turned over to 'ridge and furrow' ploughing.

The *Grace Dieu*

This is a reconstruction of the *Grace Dieu*, the flagship of Henry V built between 1416 and 1420. It was reported to have had a deck 185ft long and 50ft wide and a mast 200ft high that towered over other ships so that missiles could be rained down upon them. The height of the mast did make the ship very difficult to sail, however, and it is recorded that the crew nearly mutinied on the only voyage it made across the Solent. Thereafter it was retired from service, which was probably just as well because it was unlikely to have been much use in war.

It was moored on the River Hamble with three other ships until 1439 when it was struck by lightning and burned down to the water line. Yet this calamity did save much of the hull and until Victorian times the timbers still projected above the water at low tide. Today the timbers do not rise far above the mud line but we were able to send down divers to examine the surviving structures.

My picture shows the *Grace Dieu* at low tide in all its glory just after retirement. It would have been maintained and looked after by a crew before it caught fire and sank. The riverbank must have looked much the same then as it does now so I was able to paint it 'from life'.

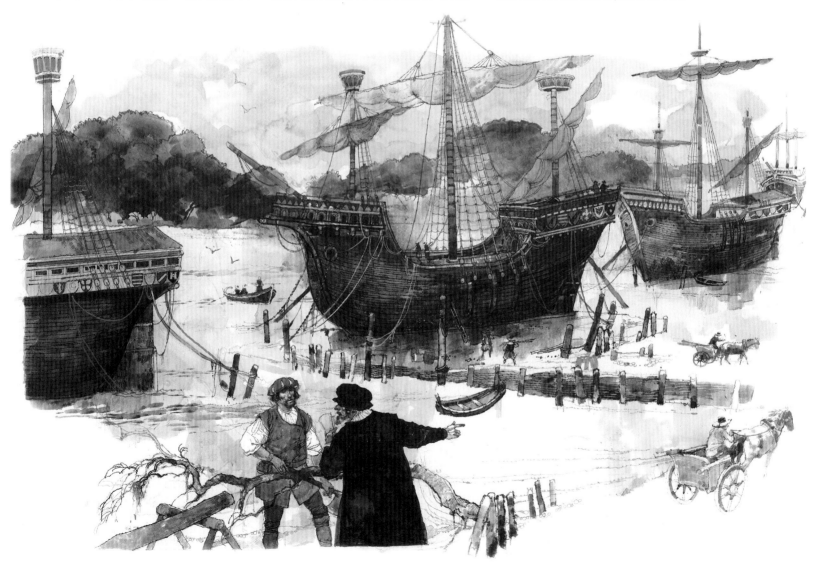

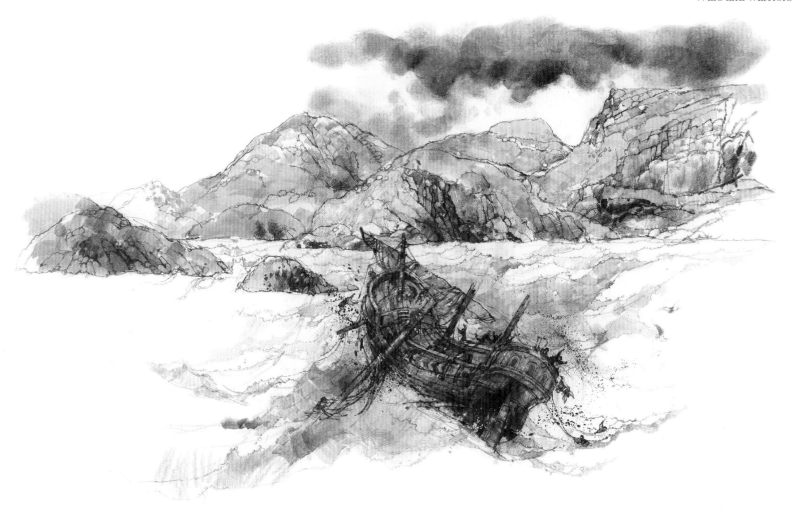

The wrecking of the *San Gabriel* at Kinlochbervie

During the great storm which wrecked the Spanish Armada in 1588 the Spanish supply vessel *San Gabriel* was wrecked in Kinlochbervie Bay off the northernmost point of Scotland. We found the cannons of the ship still scattered around the main part of the wreck and separate from this was the forecastle. Also found on the seabed were fragments of fine quality Majolica ware, which had been carried in the hold for the use by the captains and officers of the Armada.

The name 'Kinlochbervie' means 'Bay of the Strange Men' in Gaelic so it seems that there may well have been some survivors from the wreck who continued to live on the shore for a while.

I started this reconstruction propped up against the funnel of an old Scottish trawler. The sea was a little restless so although I was not exactly tied to the mast I certainly needed some support. The seashore must have changed very little since the time of the Spanish Armada so again I was able to draw it 'from life' and place the shipwreck in the foreground later.

Very few of the finds were lifted. The cannons are still lying where they sunk so some enterprising local fisherman could probably make a good living from showing tourists the site of the wreck.

It appears that the *San Gabriel* hit a rock shelf as it was driven ashore by high seas. We know from the positioning of the wreckage that it broke up just past the forecastle and that it must have gone down almost immediately. You would have had to have been a very strong swimmer to make it to the shore. Most of the crew did not.

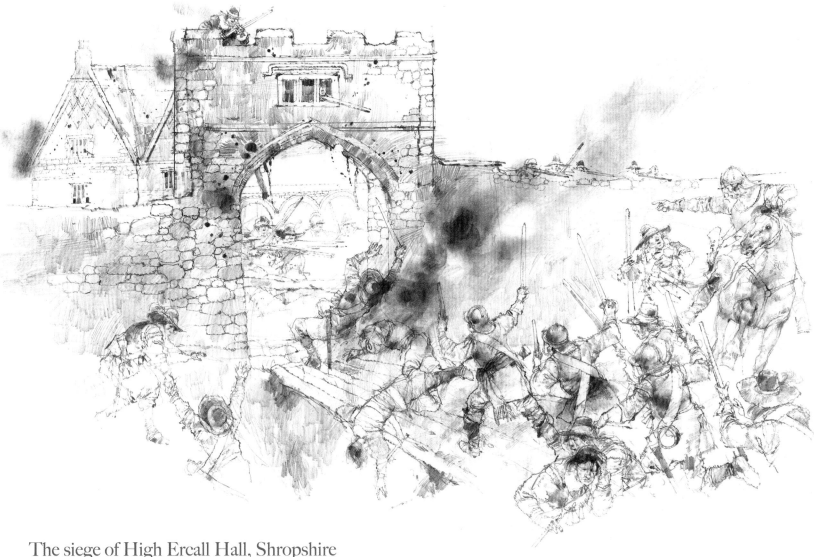

The siege of High Ercall Hall, Shropshire

The pillars from the manor house and the church tower of High Ercall still bear the musket and pistol ball scars of the repeated sieges of a royalist garrison by a much larger parliamentary army.

Excavations of the corner of the still surviving earthworks which formed the inner line of defence of the manor exposed the foundations of a stone-built gatehouse that had been used as a watch tower. From here any attempt to climb the steep ditch would have been met with withering fire from the royalist garrison. Nevertheless, numerous lead pistol balls found here provided evidence of Roundhead attacks at this point.

This reconstruction shows an attack on the gatehouse by the Roundheads. As with the sieges of other large fortified houses during the Civil War the final charges were mostly made by the cavalry using pistols and broadswords against the cumbersome muskets of the defending infantry.

The house only fell to the overwhelming numbers of Cromwell's men after the third siege when the royalist garrison of 200 or so men surrendered in order to be given safe passage to leave.

(Far left) The arches of High Ercall showed bullet damage and sword cuts

(Left) A view of High Ercall showing the church tower which was also used as a defensive fort

The Civil War incident during the Siege of High Ercell Hall, Shropshire

During the long siege of this fortified manor house, frustrated parliamentarian troops decided to send a drummer up a tree near the front line to beat the 'call of surrender' to the defenders.

This message continued to be delivered at the crack of dawn every morning in order to wear down royalist morale.

It certainly succeeded in annoying them. One morning a local man known to have been an excellent shot, loaded a tightly wrapped lead ball into his musket and at quite some distance shot the drummer right out of the tree. From then on the royalists slept soundly at dawn.

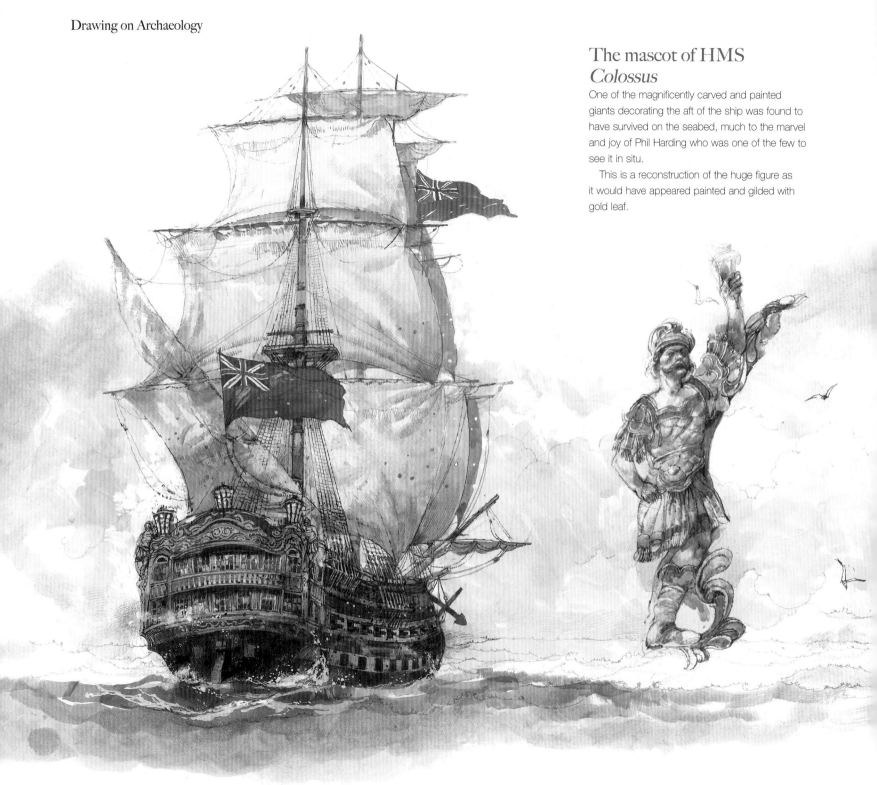

The mascot of HMS *Colossus*

One of the magnificently carved and painted giants decorating the aft of the ship was found to have survived on the seabed, much to the marvel and joy of Phil Harding who was one of the few to see it in situ.

This is a reconstruction of the huge figure as it would have appeared painted and gilded with gold leaf.

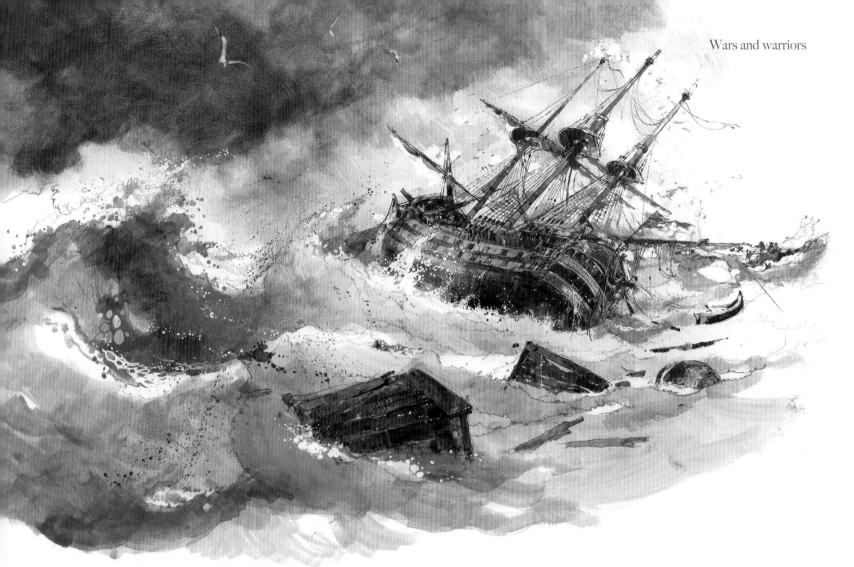

The wrecking of HMS *Colossus* off Samson, Scilly

HMS *Colossus* was a third-rate ship of the line that had received quite a battering from the Spanish during the Battle of Cape St Vincent off Portugal in 1797. The next year parts of it were cannibalised in Naples for ships damaged in the Battle of the Nile, including the spare main anchor for the flagship of Admiral Nelson. It was decided that Captain George Murray would return the ship to England for a refit, along with 200 or so sick and wounded sailors. Lady Emma Hamilton, the young wife of the elderly British Ambassador to Naples, Sir William Hamilton,

used her influence on Nelson to have eight cases of Roman and Etruscan antiquities that her husband had collected also taken on board.

A delay in port at Lisbon proved disastrous as the ship ran into a storm on approaching the Scilly Islands. Captain Murray had the anchors set at St Mary's Island to ride out the storm, but on the third day the main anchor cable parted and without a spare one the ship could not be prevented from running aground. Captain Murray then ordered the evacuation of ship in an orderly fashion which was carried out with the loss of only one man.

However, much of Sir William's cargo was lost when the ship broke up that night.

Sir William seems to have been far more distraught at this loss to archaeology than his wife becoming the mistress of Nelson. In particular he bitterly complained that the barrel of rum containing the body of Vice Admiral Lord Shuldham had been salvaged instead of more of his precious antiquities. This scene shows the shipwreck, a subject which was a joy for me to draw.

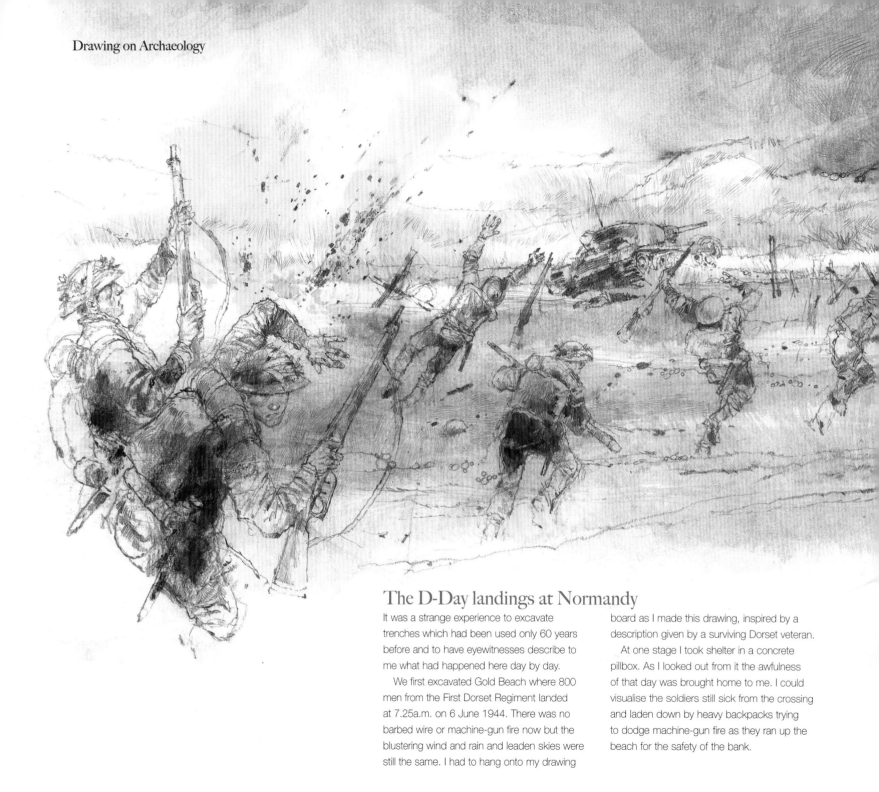

The D-Day landings at Normandy

It was a strange experience to excavate trenches which had been used only 60 years before and to have eyewitnesses describe to me what had happened here day by day.

We first excavated Gold Beach where 800 men from the First Dorset Regiment landed at 7.25a.m. on 6 June 1944. There was no barbed wire or machine-gun fire now but the blustering wind and rain and leaden skies were still the same. I had to hang onto my drawing board as I made this drawing, inspired by a description given by a surviving Dorset veteran.

At one stage I took shelter in a concrete pillbox. As I looked out from it the awfulness of that day was brought home to me. I could visualise the soldiers still sick from the crossing and laden down by heavy backpacks trying to dodge machine-gun fire as they ran up the beach for the safety of the bank.

Once off the beach, the Dorsets made their way inland to capture a high hill overlooking the countryside known as Point 54. Here they unexpectedly encountered experienced German troops, with machine guns, who were dug into trenches that overlooked the sunken lane that led to the top of the hill.

The archaeologists found evidence of a desperate fight with cartons of cartridges, machine-gun rounds, hand grenade parts, belt buckles and even razors scattered around the still clearly visible trenches.

After the Germans had held up the advance for some time the stalemate was broken by an experienced veteran of the Sicilian landings who crawled along a line of bushes and attacked them single handed. The surviving German soldiers then surrendered.

The fall of Puits d'Herode

The end of resistance in the area came when this next major fortification was attacked. After an initial burst of heavy fire on the Dorsets a white flag appeared and the German troops surrendered en masse. From their top bunker they could see nothing but dozens of allied ships with thousands of allied soldiers swarming out of them and up the beaches. They realised that for them the war really was over.

In spite of the ferocious fighting our veteran had no personal hatred of the German soldiers. "We were all there to do a job. We were in the same boat. Kill or be killed".

Making these drawings brought back vivid memories of my own childhood a long time ago in Hungary, when at the age of nine my family and I got caught up in the front line of the war. I saw troops fighting it out about fifty yards away from me, just as they appear in these pictures. These memories are still easy to recall.

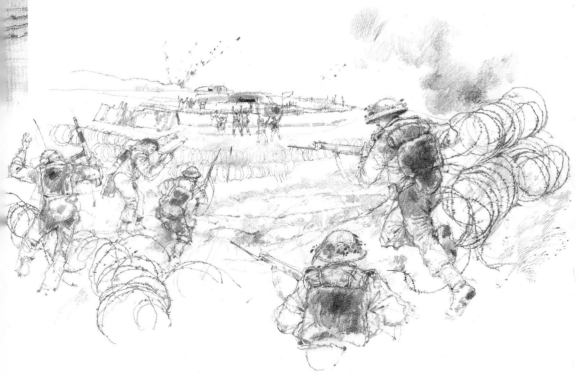

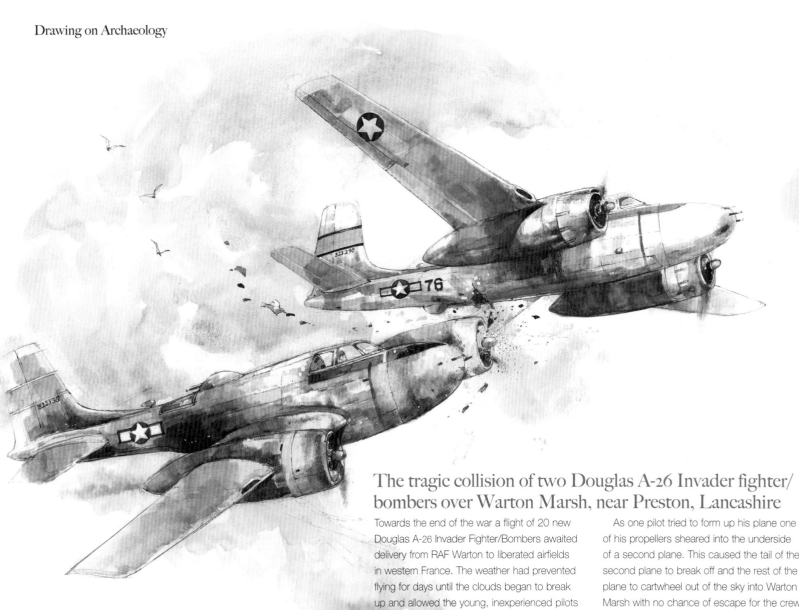

The tragic collision of two Douglas A-26 Invader fighter/bombers over Warton Marsh, near Preston, Lancashire

Towards the end of the war a flight of 20 new Douglas A-26 Invader Fighter/Bombers awaited delivery from RAF Warton to liberated airfields in western France. The weather had prevented flying for days until the clouds began to break up and allowed the young, inexperienced pilots to take off on 29 November 1944.

The Douglas A-26 was a new, heavily-armed plane that required a large and heavy engine on each wing to fly. Unfortunately these made the plane unstable and reduced the pilot's side vision. As the Invaders took off and circled around the airfield and the clouds came and went the pilots struggled to get their planes into formation.

As one pilot tried to form up his plane one of his propellers sheared into the underside of a second plane. This caused the tail of the second plane to break off and the rest of the plane to cartwheel out of the sky into Warton Marsh with no chance of escape for the crew. Meanwhile the first plane crash-landed onto the mudflats.

This was the first 'modern' archaeological reconstruction that I had ever had to illustrate and it was a very demanding one. All the details of the planes had to be correct and it took a long time to work out exactly what had happened from the dig and eyewitnesses so the drawing was only finished on the last day.

Sergeant Begonski's rescue attempt, Warton Marshes, near Preston, Lancashire

This is a reconstruction of Sergeant Begonski's attempt to rescue the pilot from the Douglas A-26 Invader fighter/bomber which crash-landed onto the mudflats of Warton Marsh.

The sergeant waded and swam across the water to reach the crashed plane as it was engulfed by flames. He managed to release the pilot from his straps and drag him to safety but unfortunately the pilot had already died from the impact of the crash. Nevertheless Sergeant Begonski was decorated for his brave rescue attempt.

I stood in front of the wreckage of the plane still mired in the same sticky black mud 60 years later to draw this dramatic scene.

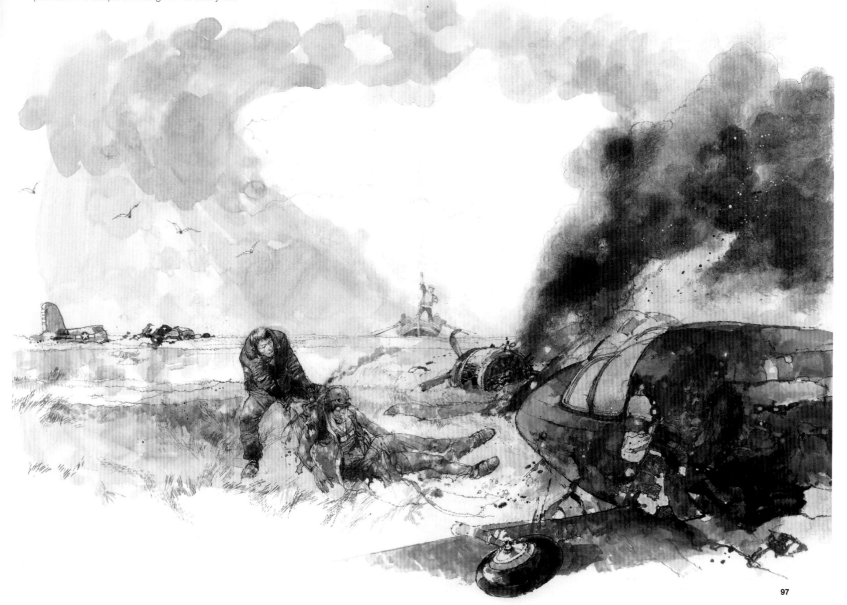

Executed man, Brading Haven, Isle of Wight

We found a dark secret at this site in the form of the skeleton of a middle-aged man in a ditch, whose body had been left in a crouched position with his hands and feet tied together.

The remains were dated to about the time the Romans took over the settlement here. The man might have committed some crime against the trading community that prospered here and been unceremoniously executed, or he might have been a victim of murder or even human sacrifice.

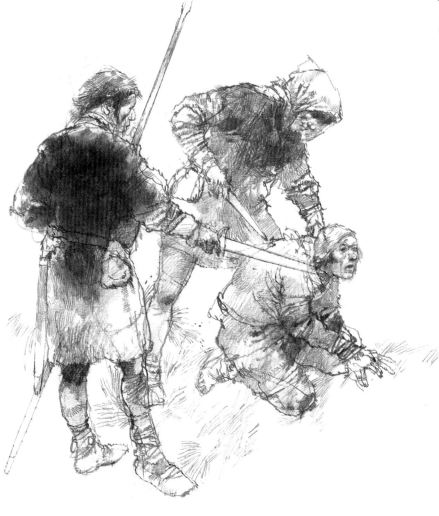

Crime and punishment

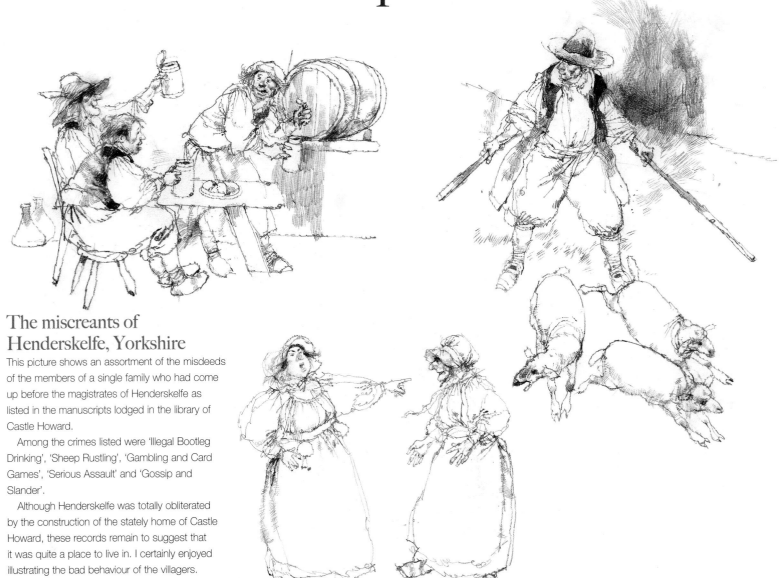

The miscreants of Henderskelfe, Yorkshire

This picture shows an assortment of the misdeeds of the members of a single family who had come up before the magistrates of Henderskelfe as listed in the manuscripts lodged in the library of Castle Howard.

Among the crimes listed were 'Illegal Bootleg Drinking', 'Sheep Rustling', 'Gambling and Card Games', 'Serious Assault' and 'Gossip and Slander'.

Although Henderskelfe was totally obliterated by the construction of the stately home of Castle Howard, these records remain to suggest that it was quite a place to live in. I certainly enjoyed illustrating the bad behaviour of the villagers.

The public flogging of Martha Philipson at Appleby, Cumberland

During the eighteenth and nineteenth centuries theft or damage to property was treated almost as severely as grievous bodily harm or even murder.

In 1791, for example, Martha Philipson was stripped to the waist and flogged while being led up and down the Appleby High Street for stealing a paltry amount of cloth. Appleby High Street is very long and steep and bad enough to have to walk up and down without being beaten all the way.

A local doctor who had shot his wife dead in a drunken range by contrast was released rather than being hung for murder. Apparently the magistrates found several reasons for leniency, such as previous good character, being under the influence of drink and not being of sound mind.

This drawing was made on a cold and wet morning at the bottom of the High Street where the market still takes place.

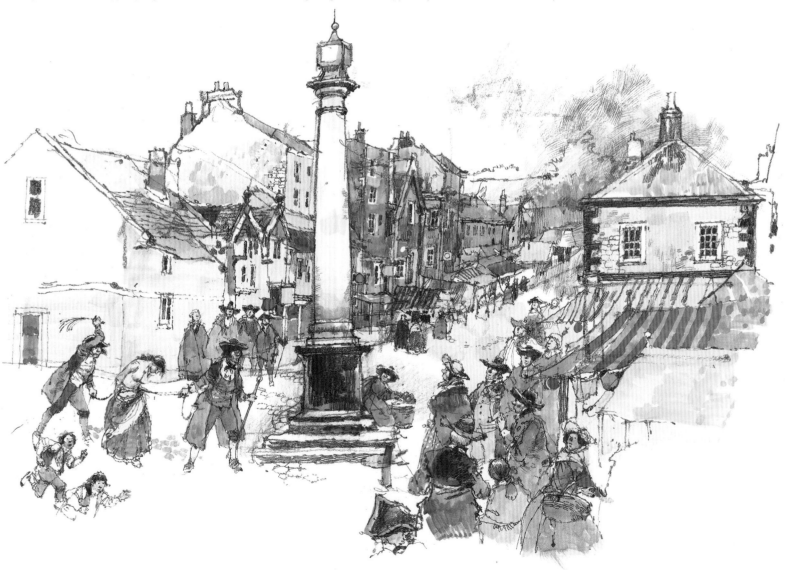

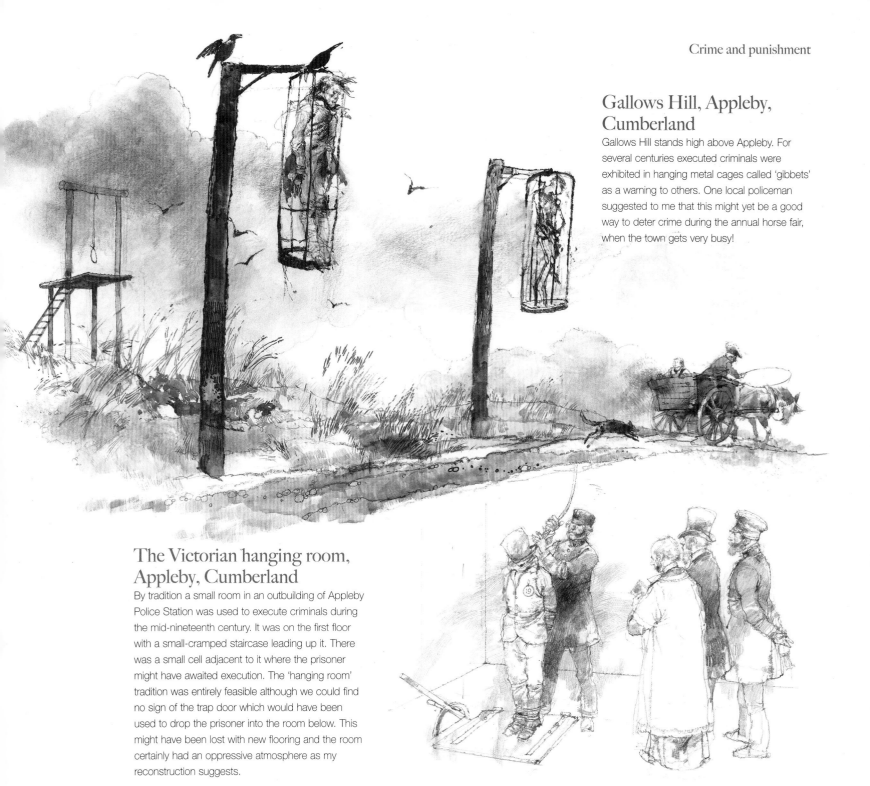

Gallows Hill, Appleby, Cumberland

Gallows Hill stands high above Appleby. For several centuries executed criminals were exhibited in hanging metal cages called 'gibbets' as a warning to others. One local policeman suggested to me that this might yet be a good way to deter crime during the annual horse fair, when the town gets very busy!

The Victorian hanging room, Appleby, Cumberland

By tradition a small room in an outbuilding of Appleby Police Station was used to execute criminals during the mid-nineteenth century. It was on the first floor with a small-cramped staircase leading up it. There was a small cell adjacent to it where the prisoner might have awaited execution. The 'hanging room' tradition was entirely feasible although we could find no sign of the trap door which would have been used to drop the prisoner into the room below. This might have been lost with new flooring and the room certainly had an oppressive atmosphere as my reconstruction suggests.

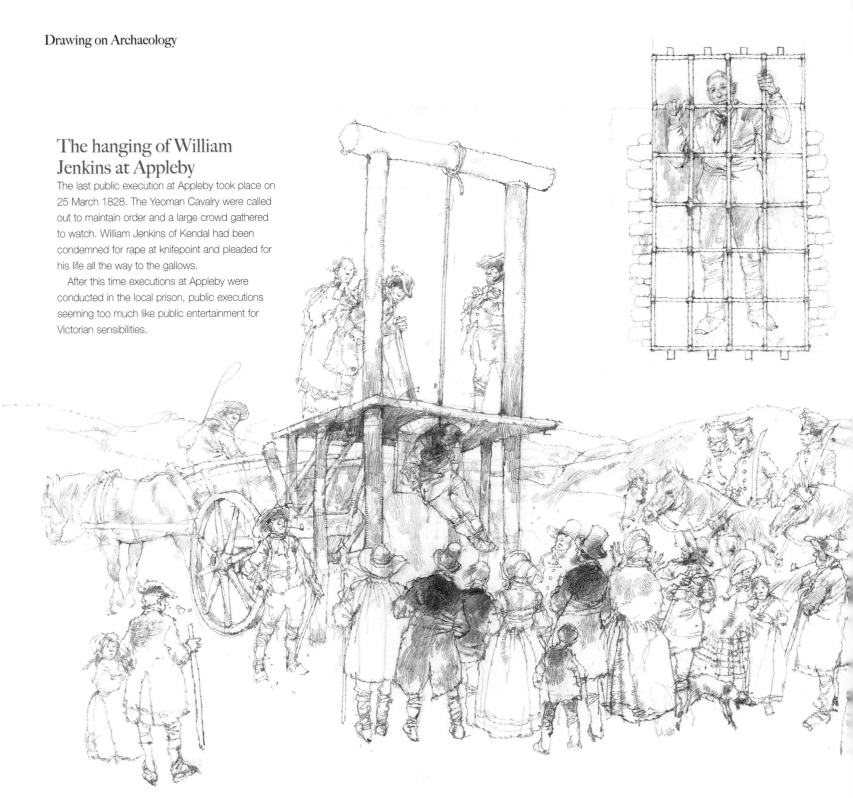

The hanging of William Jenkins at Appleby

The last public execution at Appleby took place on 25 March 1828. The Yeoman Cavalry were called out to maintain order and a large crowd gathered to watch. William Jenkins of Kendal had been condemned for rape at knifepoint and pleaded for his life all the way to the gallows.

After this time executions at Appleby were conducted in the local prison, public executions seeming too much like public entertainment for Victorian sensibilities.

Late Victorian prison cell, Appleby

This prison was an improvement in that prisoners were strictly segregated and the rooms had small, grated windows to let in the air. Each room was furnished only by a wooden bench and a sink and the only luxuries were a blanket and fresh water.

During the daytime the prisoners would exercise by either breaking up rocks in the courtyard or running on a treadmill like a hamster on a cage wheel.

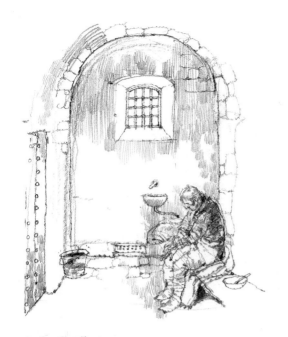

The eighteenth-century mixed prison

Large communal prisons where men and women shared a single large room as illustrated here were common in London. These were dark, smelly and airless places where disease was rife and there was no privacy. The prisoners slept on straw bedding under washing lines with rats and mice for company.

People got on as best they could and if they could afford it, bought favours from the guard or 'turnkey' such as drink and better food.

This type of prison was not dissimilar to the nineteenth-century debtors' prisons described by Charles Dickens, where whole families were often incarcerated in appalling conditions.

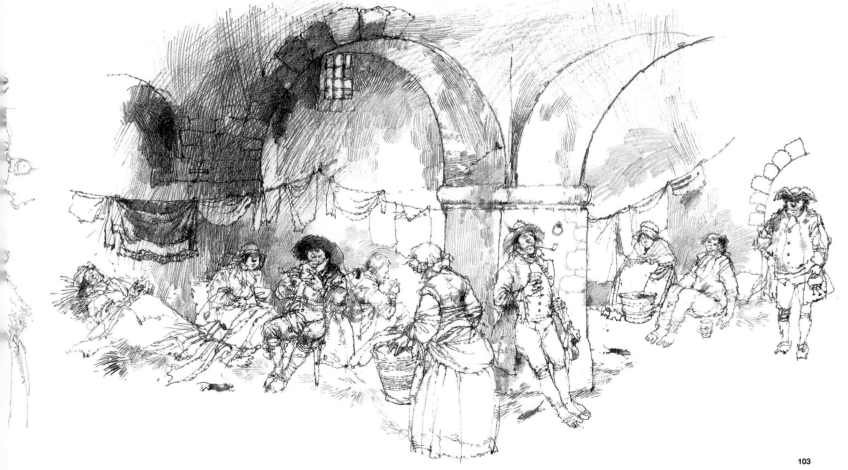

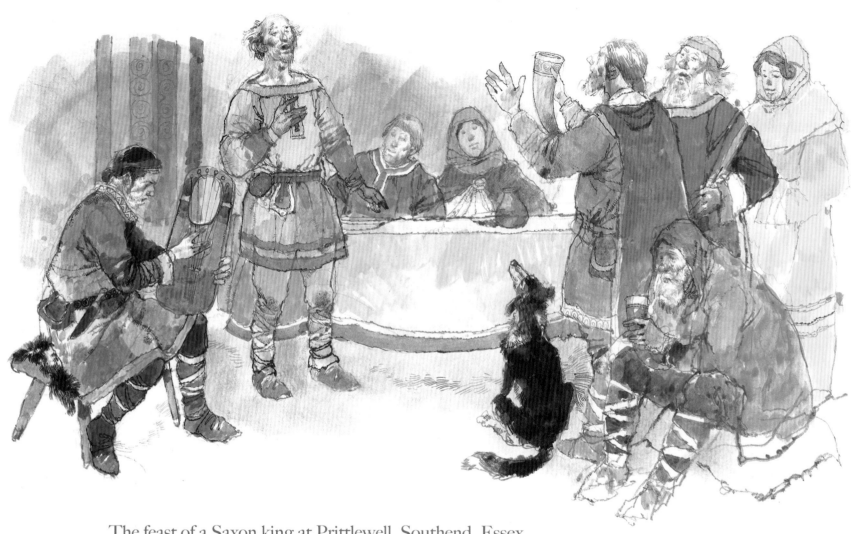

The feast of a Saxon king at Prittlewell, Southend, Essex

Playing the harp, singing and storytelling were an essential part of the Saxon dinner party during the long winter evenings. In 2003 magnificent glass bowls, gold-rimmed drinking horns and a huge number of pots and jewellery were discovered in the burial chamber of an early seventh-century Saxon king at Prittlewell, Southend. Perhaps the rarest and most exciting find, however, was the remains of a Saxon harp. This reconstruction shows the harp being put to good use at a Saxon feast.

Royalty

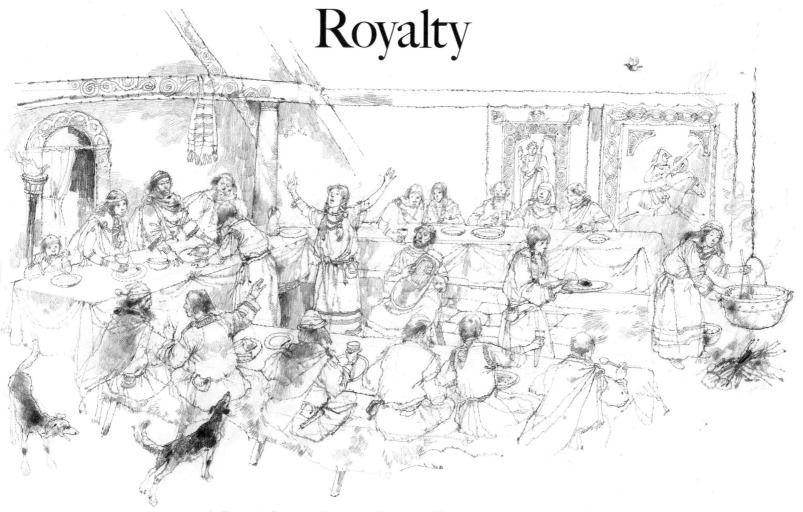

A Royal Saxon feast at Eastry, Kent

Saxon feasts were elaborate and raucous affairs held in a great hall decorated with colourful hangings and lit by torches. The servants would bring a succession of courses while a singer accompanied by a harpist recited the deeds of past heroes. The flight of small birds across the hall looking for scraps was regarded as a good omen.

Unfortunately, although a seventh-century Saxon palace is known to have existed at Eastry we were unable to locate it so this drawing remains speculative.

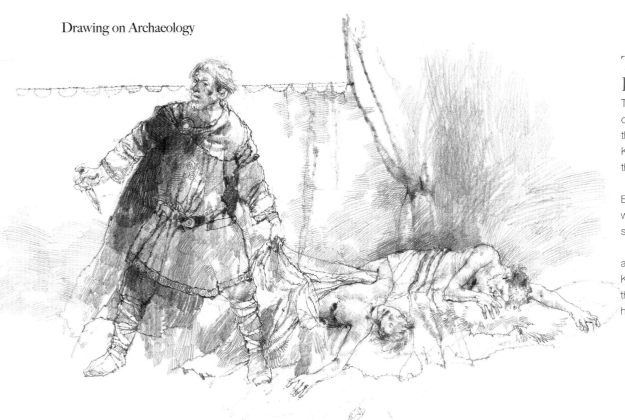

The murder of the Princes at Eastry, Kent

The murder of two young princes, but not those of the Tower of London. They were the sons of the elder brother of the Saxon King Egbert I of Kent, who had died before he could succeed to the throne.

An advisor named Thunnor had persuaded King Egbert that his claim to the throne was not safe while the princes lived and murdered them in their sleep at the Palace of Eastry.

The crime was said to have been revealed by a strange light shining over the hidden tomb, and King Egbert, in his remorse at failing to prevent the princes' murder, had them reburied with full honours.

King Alfred burns the cakes, Athelney, Somerset

This picture illustrates the story of King Alfred burning the cakes. This story first appeared in an anonymous late tenth-century manuscript and the location for it was given as the marshes of Athelney.

With so much on his mind as he fought the Danish Vikings, it was no wonder that Alfred forgot about the burning cakes, much to the annoyance of the wife of the swineherd who had put him up as a lodger.

If the story is correct then; the cakes; must have been small flat pancake-like pastries which, as we found out, were easily burnt. The biography of King Alfred written by Bishop Asser suggests that Alfred suffered from piles, and if he had to eat very many of these this might explain why.

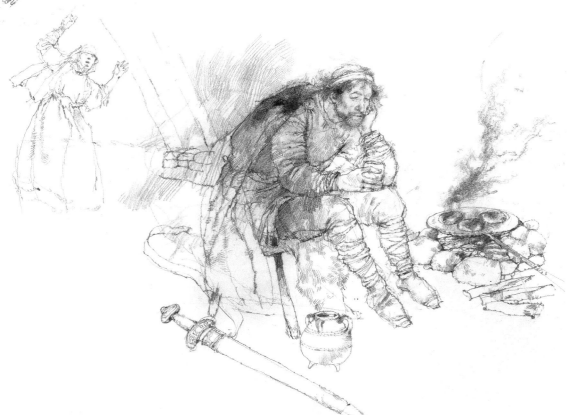

King Cnut on the beach

This drawing illustrates the story of King Cnut ordering back the tide somewhere on the south coast, perhaps near Chichester.

This incident might have actually happened. However, far from imagining that he could actually order back the tide the king had tired of the flattery of his courtiers and was demonstrating to them that not even he could give orders to the sea.

Cnut came from Denmark to rule England in 1016. He appears to have been a wise and peaceable king who ruled England so well that he was able to visit his Scandinavian lands for months on end without fear of uprising.

The birth of Edward the Confessor, Islip, Oxfordshire

Islip is recorded as being the birthplace of Edward the Confessor. Since there is no written or archaeological evidence of there ever having been a royal hall or palace here during Saxon times the archaeologists speculated that his mother Queen Emma of Normandy might have unexpectedly gone into labour while travelling through the town and given birth to him at the nearest suitable manor house.

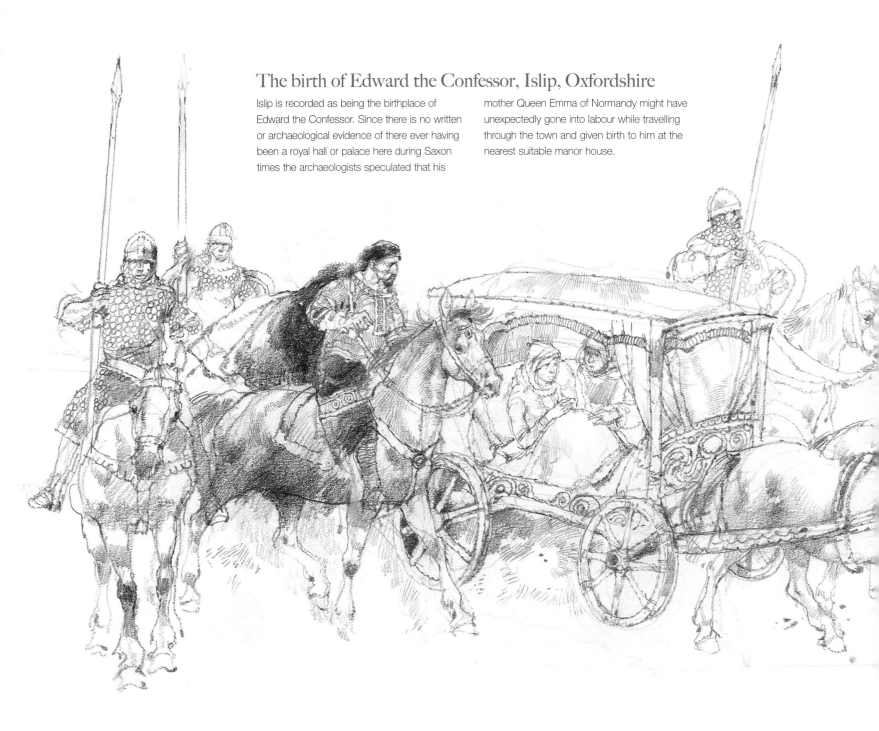

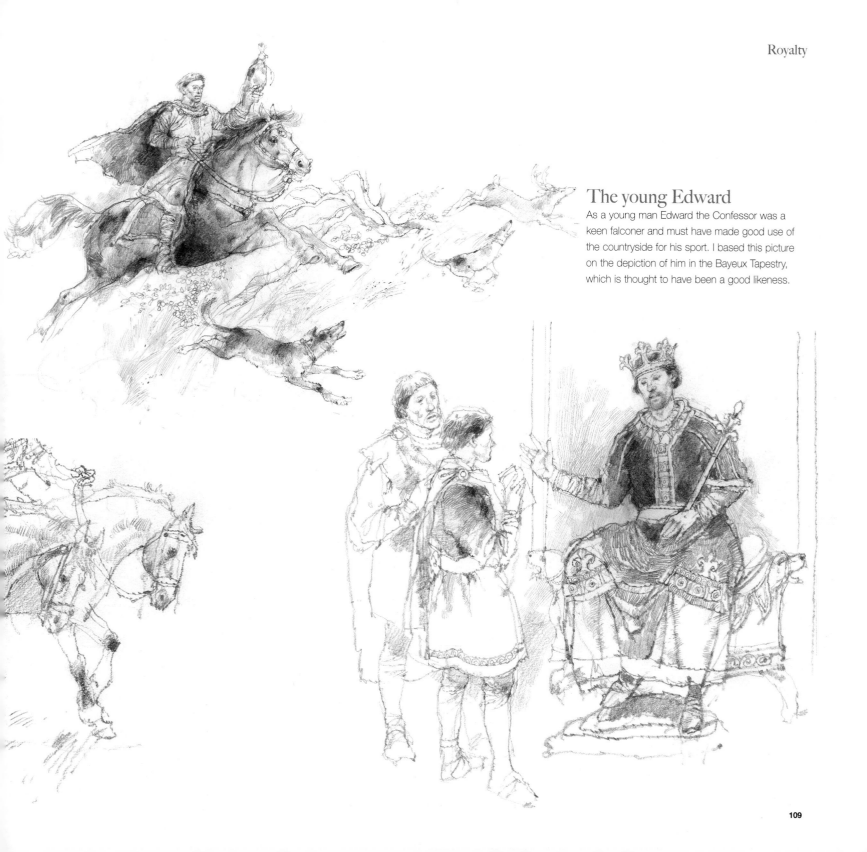

The young Edward

As a young man Edward the Confessor was a
keen falconer and must have made good use of
the countryside for his sport. I based this picture
on the depiction of him in the Bayeux Tapestry,
which is thought to have been a good likeness.

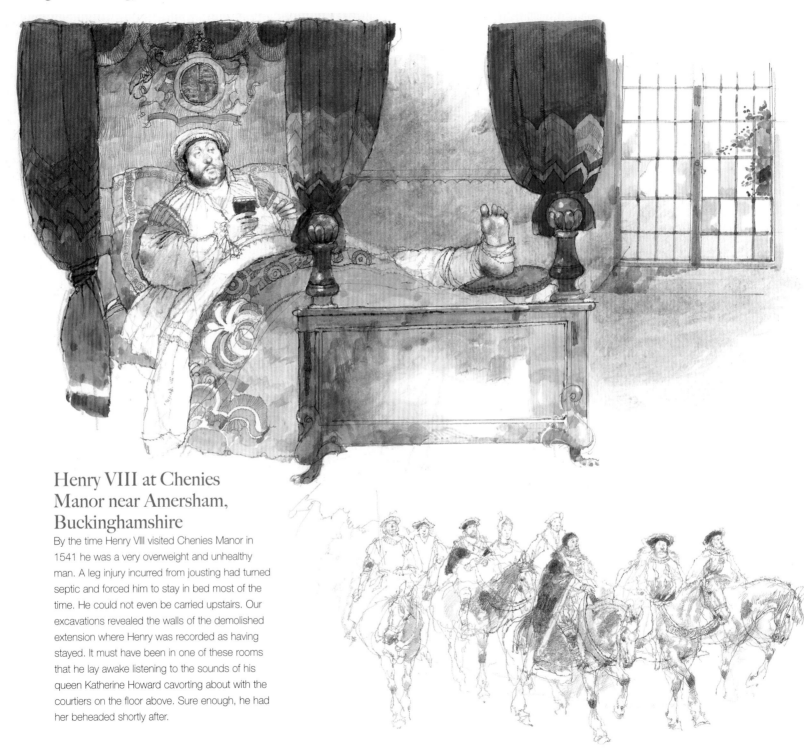

Henry VIII at Chenies Manor near Amersham, Buckinghamshire

By the time Henry VIII visited Chenies Manor in 1541 he was a very overweight and unhealthy man. A leg injury incurred from jousting had turned septic and forced him to stay in bed most of the time. He could not even be carried upstairs. Our excavations revealed the walls of the demolished extension where Henry was recorded as having stayed. It must have been in one of these rooms that he lay awake listening to the sounds of his queen Katherine Howard cavorting about with the courtiers on the floor above. Sure enough, he had her beheaded shortly after.

Tudor falconry

Falconry was an immensely popular medieval and renaissance pastime that was re-enacted for us by professional falconers in Tudor costume at Chenies Manor, near Amersham, Buckinghamshire.

Henry VIII himself is known to have become a keen falconer during his later years when he became too old for jousting and hunting, and a falconry glove that is reputed to have been his still survives at the Ashmolean Museum, Oxford.

I took the opportunity to make drawings as the demonstration proceeded. The hooded hawk perched on the falconer's left hand was an eight-month-old harrier who sat patiently for me while I drew it in the tent.

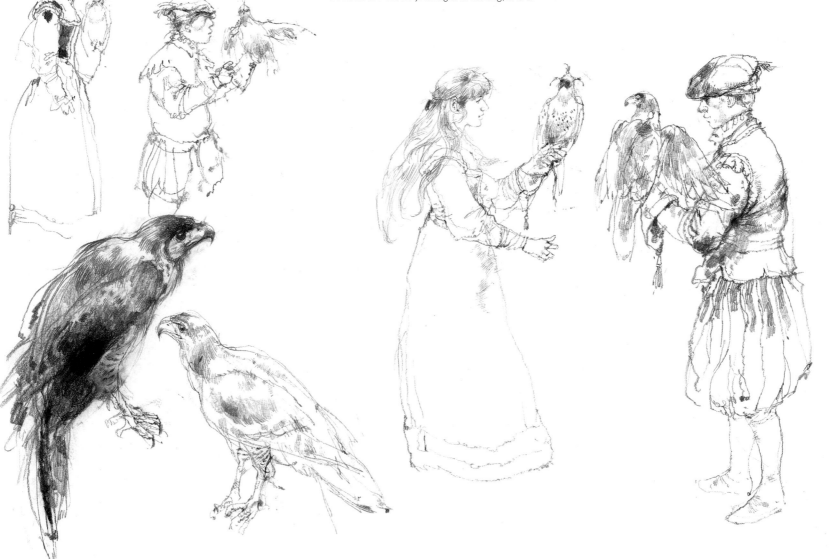

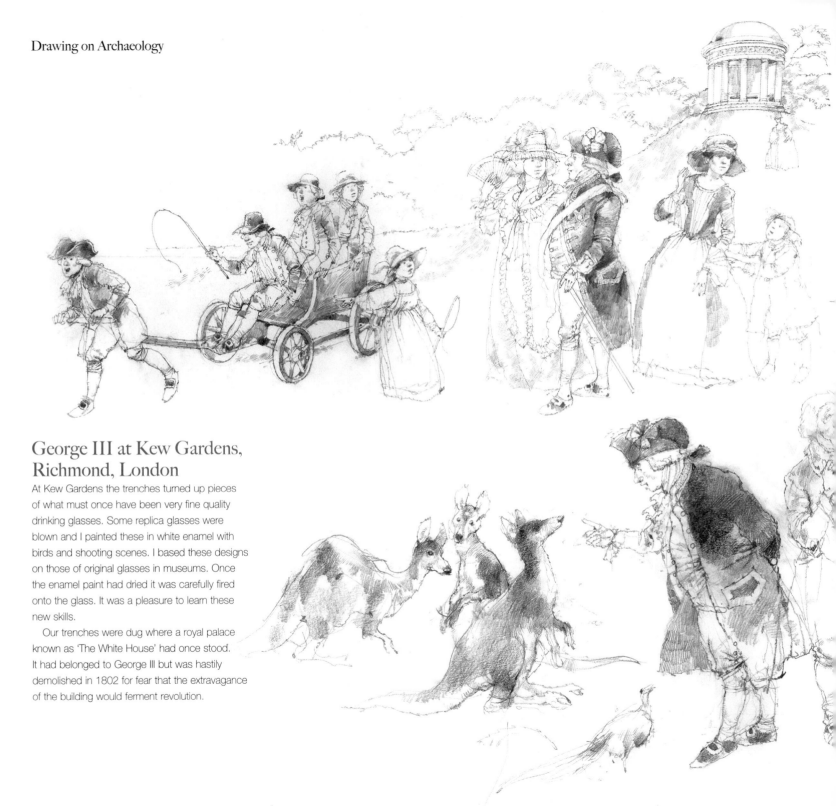

George III at Kew Gardens, Richmond, London

At Kew Gardens the trenches turned up pieces of what must once have been very fine quality drinking glasses. Some replica glasses were blown and I painted these in white enamel with birds and shooting scenes. I based these designs on those of original glasses in museums. Once the enamel paint had dried it was carefully fired onto the glass. It was a pleasure to learn these new skills.

Our trenches were dug where a royal palace known as 'The White House' had once stood. It had belonged to George III but was hastily demolished in 1802 for fear that the extravagance of the building would ferment revolution.

Prince Regent

King George III had his many children brought up in his palace at Kew by a strict German governess named Frau Pappendick. It was hardly surprising that as soon as her tight control was relinquished, the young princes turned to all manner of self-indulgence and profligacy. The Prince of Wales (later Prince Regent and then George IV) became quite obese. The result of good port was often bad gout, as illustrated in this sketch!

Unfortunately George III was by now afflicted by physical illness and 'madness' and the remedies he was prescribed by his doctors were almost as bad his maladies.

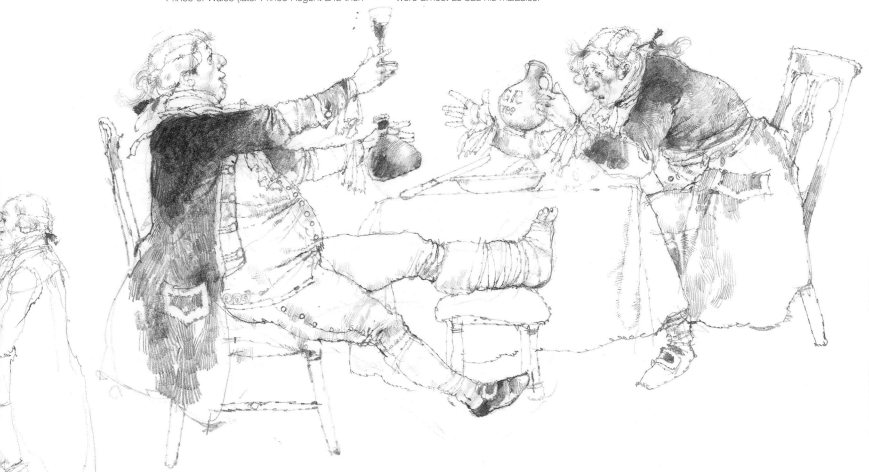

King George III and his kangaroos, Kew Gardens, London

George III was very taken by the kangaroo that he been presented with in 1792 by Arthur Phillip, the Governor of New South Wales. He acquired others and by the end of the next year they had started to breed in a 3-acre paddock at Kew. Although kangaroos only give birth to one young at a time they can do so in rapid succession. Soon the king had so many of them that he had to start presenting them to courtiers and aristocrats. One wrote to another complaining that the king had presented him with yet another of his blessed kangaroos!

George III also liked to talk to his favourite animals, much to the consternation of his doctors who regarded this as yet another symptom of his mental illness.

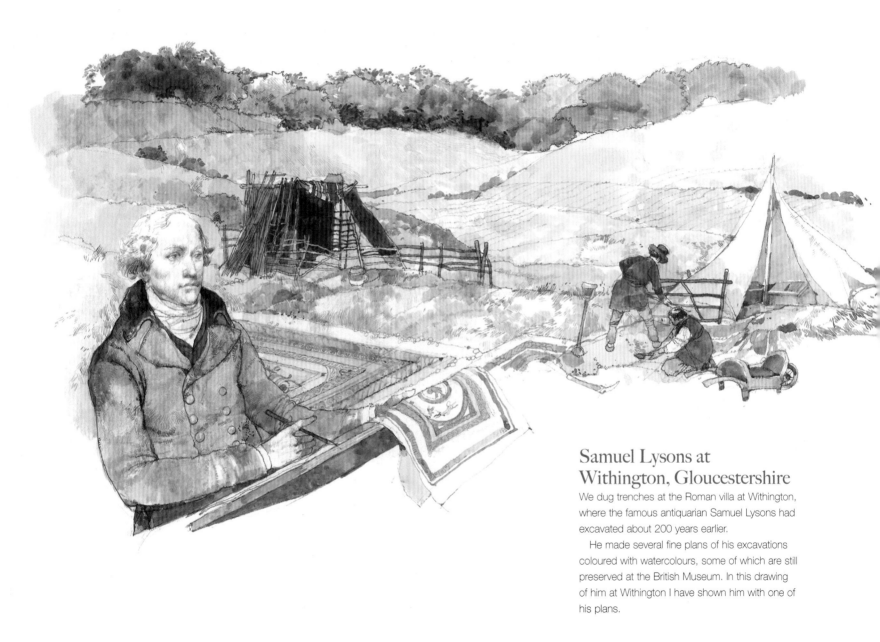

Samuel Lysons at Withington, Gloucestershire

We dug trenches at the Roman villa at Withington, where the famous antiquarian Samuel Lysons had excavated about 200 years earlier.

He made several fine plans of his excavations coloured with watercolours, some of which are still preserved at the British Museum. In this drawing of him at Withington I have shown him with one of his plans.

The antiquaries

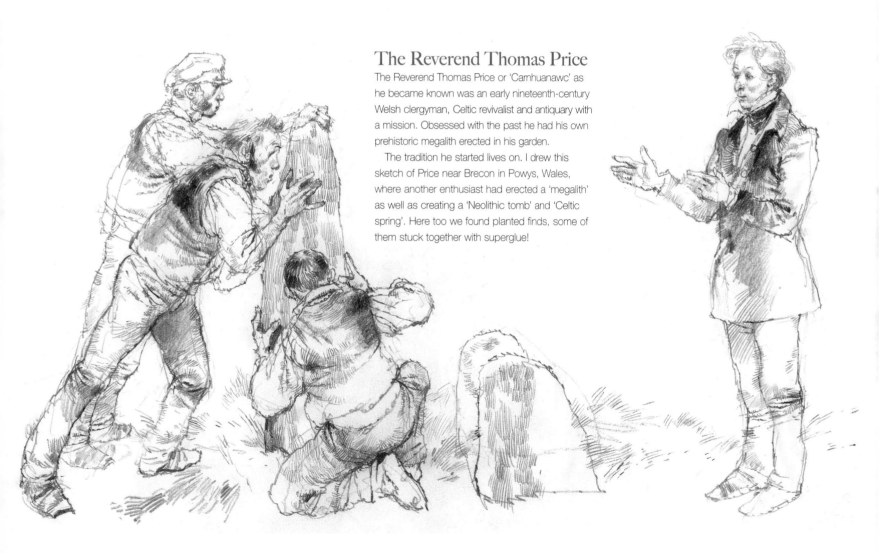

The Reverend Thomas Price

The Reverend Thomas Price or 'Carnhuanawc' as he became known was an early nineteenth-century Welsh clergyman, Celtic revivalist and antiquary with a mission. Obsessed with the past he had his own prehistoric megalith erected in his garden.

The tradition he started lives on. I drew this sketch of Price near Brecon in Powys, Wales, where another enthusiast had erected a 'megalith' as well as creating a 'Neolithic tomb' and 'Celtic spring'. Here too we found planted finds, some of them stuck together with superglue!

The Elton family and the Roman bath house at Whitestaunton, Somerset

During the nineteenth century the Elton family were proud of what they thought were the remains of a Roman villa by a fast-flowing stream in the grounds of their magnificent late medieval mansion at Whitestaunton. Charles Isaac Elton in particular took great interest in the remains and their associated artefacts and in 1883 he recorded these within a local archaeological journal.

Unfortunately his less conscientious nephew decided to 'improve' the ruins in Edwardian days by bringing in Roman material from other sites.

During the excavation we had to work through unrelated Roman columns, tiles and pottery set in modern cement before we reached the original remains of what proved be a Roman bathhouse. The associated villa could not be located but it may have been under the mansion itself.

Looking for Roman burials near the wall in Bath

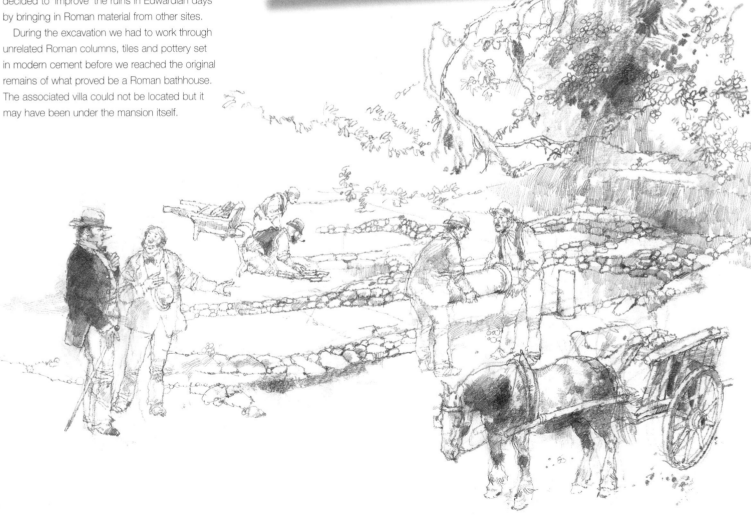

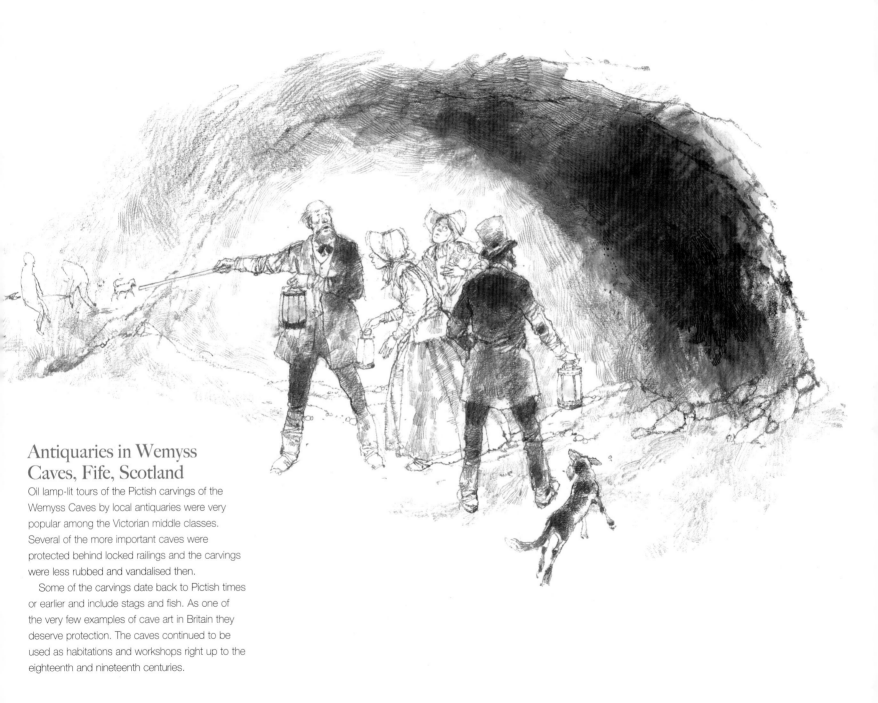

Antiquaries in Wemyss Caves, Fife, Scotland

Oil lamp-lit tours of the Pictish carvings of the Wemyss Caves by local antiquaries were very popular among the Victorian middle classes. Several of the more important caves were protected behind locked railings and the carvings were less rubbed and vandalised then.

Some of the carvings date back to Pictish times or earlier and include stags and fish. As one of the very few examples of cave art in Britain they deserve protection. The caves continued to be used as habitations and workshops right up to the eighteenth and nineteenth centuries.

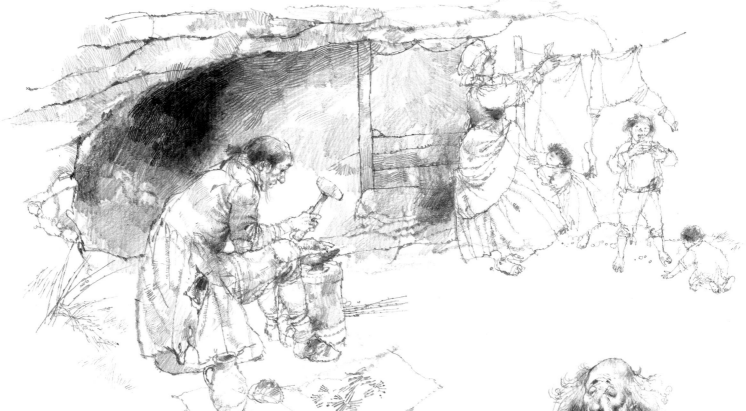

'Jonathan the Nail Maker', Wemyss Caves, Fife, Scotland

The caves had many tenants over the centuries. During the eighteenth century a man called Jonathan lived with his large family in one, making nails of all shapes and sizes.

Our archaeologists discovered many examples of his craft on the cave floor, a nice link back to the hardworking man who lived there 250 years ago.

The 'Hermit's Pool', Wemyss Caves, Fife, Scotland

Hermits are also recorded as living in the caves. One interesting stone-lined basin we excavated may have served as a plunge pool. I made this highly speculative drawing of a happy hermit taking his bath.

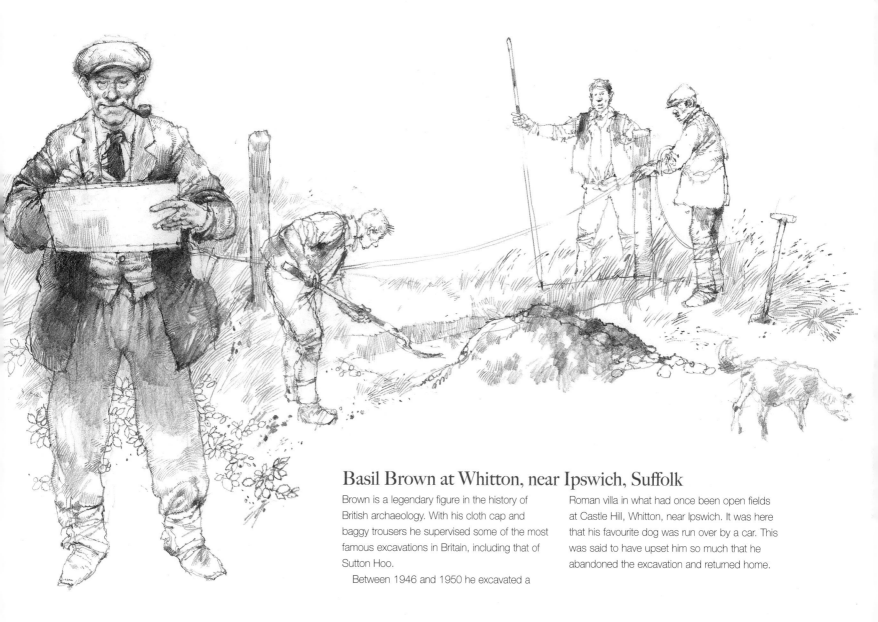

Basil Brown at Whitton, near Ipswich, Suffolk

Brown is a legendary figure in the history of British archaeology. With his cloth cap and baggy trousers he supervised some of the most famous excavations in Britain, including that of Sutton Hoo.

Between 1946 and 1950 he excavated a Roman villa in what had once been open fields at Castle Hill, Whitton, near Ipswich. It was here that his favourite dog was run over by a car. This was said to have upset him so much that he abandoned the excavation and returned home.

Index

Alfoldean 64, 65
Alfred, King 67, 106
Amersham 110, 111
Ancaster 37
Angel Street 72, 73
Appleby 100, 101, 102, 103
Applecross 78
Arun, River 64
Athelney, Isle of 67
Avon, River 30

Brown, Basil 48, 119
Bath 46, 47, 116
Beaudesert Castle 80, 81
Beauport Park 24
Berwick-upon-Tweed 53
Blackpatch Hill 14
Brading Haven 98
Brading Haven 98
Braemore 38, 66
Brecon 115
Brentford 45
Boudicca 86

Cade, Jack 82
Caesar, Julius 11, 35
Canterbury 54, 70
Cape St Vincent 93
Carsington 28, 29
Castle Hill 48, 119
Castle Howard 27, 99
Castle Hill 48, 119
Charterhouse 61
Chenies Manor 110, 111
Cheshunt 63
Chichester 64, 107
Claudius 61, 85
Cnut, King 23, 107

Colchester 51, 86
Creswell Crags 10
Cromwell 82, 90
Crosan, River 78

Dio Cassius 85
Drumlanrig Castle 76, 84
Dumfries 76
Durrington Walls 30

Eastry 66, 105, 106
East Wall Farm 69
Edward the Confessor 55, 108, 109
Edward I 52
Edward III 82
Egbert I of Kent 106
Elton, Charles Isaac 116
Emperor Nero 86
Esher Palace 70

Fetlar 44,45
Fife 17, 34, 35, 35, 117, 118
Flag Fen 32
Floors Castle 53
Forkbeard, Sweyn 107
Furnace Cottage 68

Galloway 76
Gallows Hill 101
Gear Farm 21
George IV 113
George III 112, 113
Giant's Grave 44
Gold Beach 94
Goldcliff 11, 13
Gordon's Lodge 25
Green Island 58

Gresham Street 62
Guthrum 67

Hamble, River 88
Hamilton, Lady Emma 93
Hamilton, Sir William 92, 93
Hanslope 25
Helford 21
Henderskelfe Village 27, 99
Henley-in-Arden 80
Henry III 55
Henry VII 53
Henry V 88
High Ercall Hall 90
Howard, Queen Katherine 110

Ipswich 48, 119
Isle of Wight 98
Islip 54, 55, 108

Jenkins, William 102
Jonathan the Nail Maker 118

Kew Gardens 112, 113
Kinlochbervie Bay 89

Leven 17, 34, 35
Lincoln 33, 37
Little Wittenham 36
London 56, 62, 64, 70, 82, 86, 103, 106, 112, 113
Lysons, Samuel 114

Manchester 72, 73
Matilda, Queen 108
Medway, River 82
Mendip Hills 61
Migdale, Loch 19

Murray, Captain George 93

Nasington Manor House 23
Nelson, Admiral 93
Nether Poppleton 42
New Forest 38
Nith, River 76
Northborough 14

Oakamoor 68, 69
Orkney 16

Palace of Eastry 106
Pappendick, Frau 113
Peterborough 32
Philippa, Queen of Hainault 82
Philipson, Martha 100
Poole Harbour 58
Preston 96, 97
Price, Thomas 115
Prittlewell 104
Pull, John Henry 14

Queenborough Castle 82, 83
Queenborough Green 82

Raunds 40
Rhineland 38
Richmond 112

Samson 93
Scilly 93
Severn Estuary 11
Shetlands 44, 45
Sheppey, Isle of 82, 83
Shuldham, Lord 93
Skara Brae 16
Skipsea 10, 59, 86, 87

Skye, Island of 78
South Carlton 41
Southend 104
South Parrot 31
St Albans 86
Standish 20
Stane Street 64
St Osyth 71
Suetonius 86
Sutherland 19
Sutton Hoo 48, 119
Syndale Park 85
Syon House 45

Tacitus 86
Taylor, John 83
Teviot, River 52
Thames, River 82, 83, 85
Thunnor 106
Throckmorton 22
Tower of London 82, 106
Tweed, River 52
Tyler Hill 70

Viridio 37

Warton Marsh 96, 97
Watling Street 63
Wemyss Caves 117, 118
Wester Ross 78
White House, The 112
Whitestaunton 116
Whitton 48, 119
William the Conqueror 87
Winchester 38, 55
Withington 114
Wittenham Clumps 36